To BARBIE
on her 23rd birthday, November 30, ____

Papa.
Mama John

Lisa

James

Grandma Moses

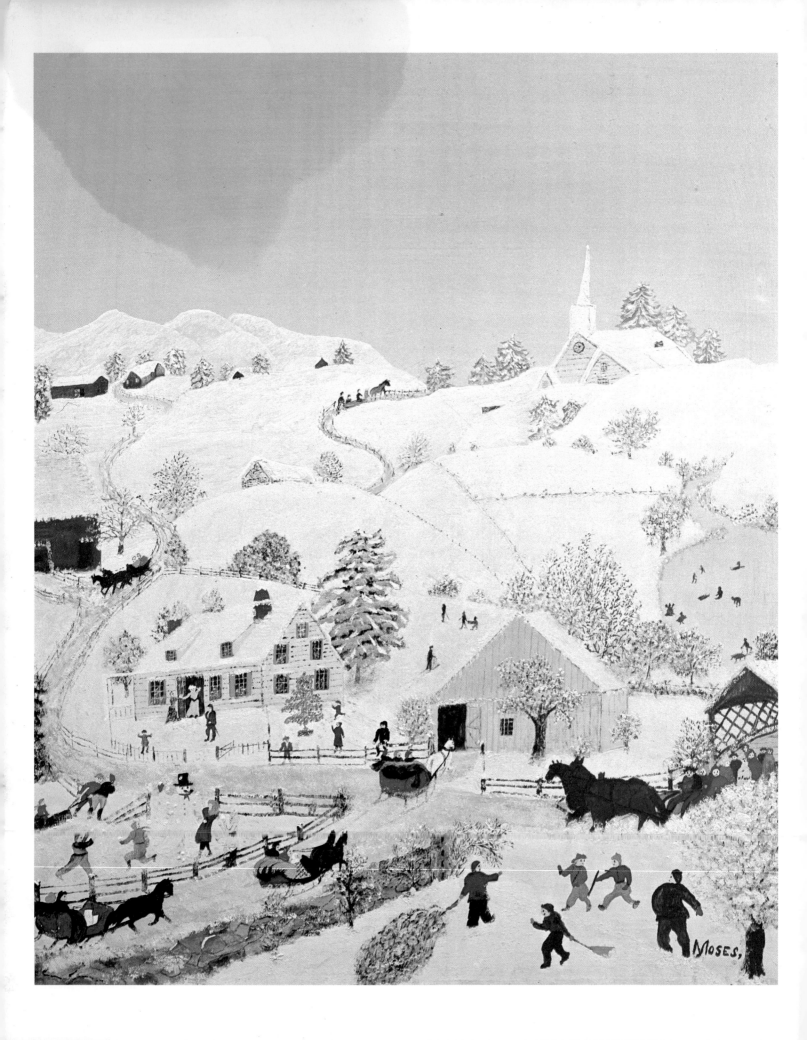

OTTO KALLIR

Grandma Moses

NEW CONCISE NAL EDITION

HARRY N. ABRAMS, INC.
PUBLISHERS, NEW YORK

DISTRIBUTED BY NEW AMERICAN LIBRARY

Frontispiece: *White Christmas.* 1954. 23¾ x 19¾".
Collection Mr. and Mrs. Irving Berlin

Nai Y. Chang, *Vice-President, Design and Production*
John L. Hochmann, *Executive Editor*
Margaret L. Kaplan, *Managing Editor*
Barbara Lyons, *Director, Photo Department, Rights and Reproductions*
Ann Goedde, *Index*
Christy S. Nettles, *Designer*

Library of Congress Cataloging in Publication Data
Kallir, Otto
　Grandma Moses.

　An abridgment of the 1973 ed. published by Abrams.
　1. Moses, Anna Mary (Robertson) 1860-1961. I. Mo-
ses, Anna Mary Robertson, 1860-1961.
ND237.M78K322　　　759.13　　　74-31269
ISBN 0-8109-2053-0

Library of Congress Catalogue Card Number: 74-31269
Text copyright © 1973, 1975 by Otto Kallir
Illustrations copyright © 1973, 1975 by Grandma Moses Properties, Inc.,
24 West 57th Street, New York, N.Y. 10019

The excerpts from Grandma Moses's *My Life's History*, 1952, edited
by Otto Kallir, are reprinted by permission of Harper & Row, New York.
The excerpts from Edward R. Murrow's interview with Grandma Moses
on "See It Now," 1955, are quoted by permission of CBS News

Acknowledgments

My thanks, above all, go to

HILDEGARD BACHERT

whose intimate acquaintance with Grandma Moses and her art and whose longtime collabora-
tion with me have greatly helped me in writing this book,

to

NANCY GARNIEZ

for her constructive assistance, especially in the compilation of the data,

and to

MY WIFE

for the invaluable help and understanding she has given me throughout.

Special mention should be made of those who very early recognized the unique quality of
Grandma Moses's art and helped to make her known: Louis J. Caldor, the artist's "discoverer,"
Sidney Janis, Allen Eaton, Thomas J. Watson, and Ala Story.

I recall with gratitude the members of Grandma Moses's family for making available over the
years much documentary material, particularly records and letters which were used in the
preparation of this book: Winona R. Fisher, Loyd R. Moses, Forrest K. Moses, Hugh W. Moses,
Dorothy Moses, Fred E. Robertson, and Mrs. B. Russell Robertson.

Grateful acknowledgment is made to the museums which furnished photographs and data on
paintings: The Phillips Collection, Washington, D.C.; The Metropolitan Museum of Art, New
York; Museum of Art, Rhode Island School of Design, Providence; Memorial Art Gallery of the
University of Rochester, N.Y.; New York State Historical Association, Cooperstown; The
Shelburne Museum, Shelburne, Vt.; The Bennington Museum, Bennington, Vt.; The Fine Arts
Gallery of San Diego, Calif.

Special appreciation is expressed to Dr. Armand Hammer, Victor J. Hammer, and his staff for
their helpful cooperation, as well as to all the collectors who have supplied information on the
Grandma Moses works in their possession.

Finally I wish to thank all those who have made possible the publication of this book,
especially Harry N. Abrams and Fritz Landshoff, as well as Nai Y. Chang, who contributed the
artistic design. Valuable assistance was given by Geoffrey Clements, who photographed many
paintings in color and black and white.

CONTENTS

PART III *Fame*

PART IV *The Range of Grandma Moses's Art*

Author's Note

IN THIS BOOK AN ATTEMPT IS MADE to present and examine the art and personality of Anna Mary Robertson Moses. The author's close contact with the painter over a period of more than twenty years and his intimate knowledge of her work have made this undertaking possible. Since the first New York show all documentary material pertaining to the artist and her work has been preserved, thus forming the basis for a systematic study. Pertinent information previously published in books and articles has also been included. Nearly sixteen hundred pictures, created between the years 1918 and 1961, are catalogued, and many of them reproduced. The more awkward attempts, the sketchy small pictures, the incomplete works are shown along with the refined, finished paintings, for all are of interest in forming a valid impression of Grandma Moses's oeuvre.

It will be seen how the compelling urge of an old woman never to remain idle after having worked hard all her life, but to make something pretty and pleasing for her own enjoyment and the pleasure of those around her developed into an all-inclusive, consciously planned creative activity.

The art and personality of Grandma Moses are inseparable. Her paintings remain for everyone to see and judge for himself. Her personality, however, can best be evoked by her own writings—letters and autobiographical notes—and through first-hand reports of those who met her personally. Particular emphasis has therefore been laid upon the evidence of people who were able not only to describe her appearance and behavior, but also to find and uncover the roots of her vitality and strength.

1

BEGINNINGS

Unless otherwise noted, all works are in oil and tempera on Masonite or cardboard.

"I, Anna Mary Robertson..."

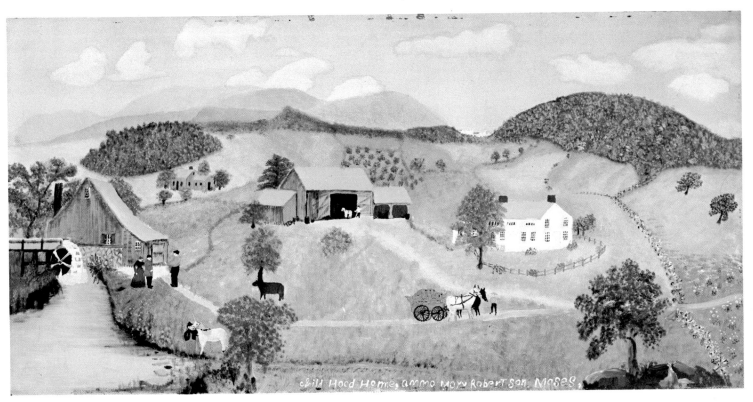

2. *The Childhood Home of Anna Mary Robertson Moses.* 1942. 14 x 28". Formerly collection Louis J. Caldor

I anna Mary Robertson, was born
back in the green meadows and wild
woods, on a Farm in Washington, co.
In the year of 1860, Sept 7,
of Scotch Irish Paternal ancestry.
Here I spent the first ten years
of my life with mother Father
and Sisters and Brothers,
those were my Happy days, free
from care or worry, helping

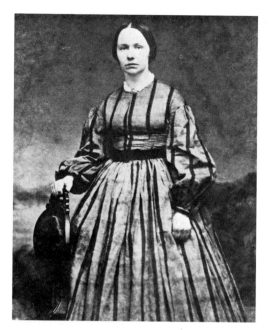

3. Anna Mary's mother,
Mary Shannahan Robertson

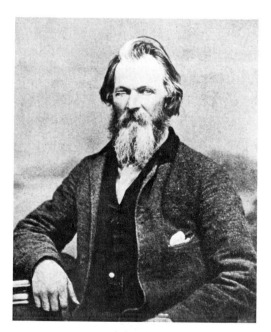

4. Anna Mary's father,
Russell King Robertson

mother, rocking Sisters creadle
taKing sewing lessons from
mother sporting with my Brothers.
making rafts to float over the
mill pond,
Roam the wild woods gathering
Flowers, and building air castles,
 1870,
now came the hard years,
Schooling was in those days in
the country three months in
summer, three in winter,
little girls did not g to school
much in winter, owing to the
cold, and not warm enough
clothing, there for my School days
were limited,
altho I was Kept busy helping at
Home, and the neighbors,
 when twelve years of age I left
Home to earn my own living as
then was called a hired girl,
 This was a grand education
for me, in cooking, House
Keeping, in moralizeing and
mingleing with the out side world,

 I went to live with a Family by
the name of mrs & mr Thomas
white sides, they were lovely
people, while well along in
years,

I was cared for by them as a
child of thair one,
 Presbyterians by creed,
one of my duties was to drive the
Horse "old black joe" to church for
them on Sunday mornings, and
place boquets on the Pulpit in
the church, and always remember the
text,
living with the whitesides,
for three years, caring for
mrs whiteside who was an invalid
and died,
 Then I Kept house for mr white
side for a year till his nephue
and wife could come and take
care of the Farm, and Him,
 I was very proud in those days,
could get up such fine dinners,
for his Friends who came from far off
to see Him,

 when the minster came and I
could bring out the fine linen and
the china tea set, and the heavy
Silver, then with hot bisquits
home mad butter and Haney, with Home
cured dryed beef, I was proud,
 But I some times now, think they
came for eats more than to see Him,
 then mr whiteside died,
and I drifted away from that
neighborhood,

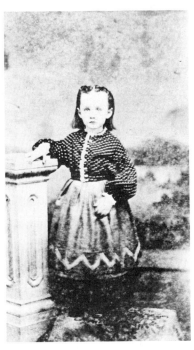

5. Anna Mary at the age
 of four

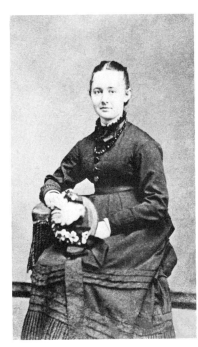

6. Anna Mary at the age
 of fifteen

7. Anna Mary as a bride, 1887

8. Thomas Salmon Moses, the bridegroom, 1887

1880
Still woorking as a hired girl, and
care ing for the sick
. Those were busy days,

In the Fall of 1887,
nov 9 I married Thomas Solmon moses,
a Farmer by occupation
we left on our wedding trip for
north carolina- to take charge of
of a Horse ranch in north carolina,
But we never reached there,
we were Kidnaped at Staunton, v, a.

or I should say over perswaded,
to go no father south
So we hired a Farm near Staunton
verginia for a year to see if we
would like the south,
and the people there were over
anxious for northeners or westners to
come in and build up the State,
They were in a way helpless
sence the colored help had been
taking from them,
we remained on this Farm one
year, then moved farther down
the valley on to a six hundred
arre dairy Farm,
Here I commenced to make Butter
in pound prints and ship it to
the white Sulphur Springs, w, va,
I also made potato chips, which was
a novelty in tho days,
this we continued for several years.
Here our ten children were Born,
and there I left five little graves
in that beautifull Shenadoah valley,

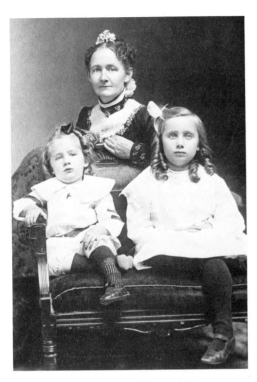

9. Anna Mary Moses with two of her youngest children, Hugh and Anna, c. 1904

Coming to new york State Dec 15, 1905, with our five children to educate and put on thire one footing,

we bought a Farm and went in to the dairy business selling milk, and doing generel Farm woork,

Here my oldest daughter married and left Home, Here my two oldest sons bought a Farm and struck out for them selves,

Here Jan 15, 1927. my Husband died, my yongest son and wife taking over the Farm,

Leaving me unoccupied, I had to do somthing, so took up painting pictures in worsted, then in oil,

This autobiographical sketch was written by Anna Mary Robertson Moses in 1945. It is an outline of the years up to her husband's death in 1927, that is to say, the time preceding her career as a painter.

The astonishing story of Anna Mary Robertson Moses's development has aroused the interest of the American and the European public for more than three decades. As "Grandma Moses" she has become known all over the world. Wherever her pictures were shown, they met with exceptional response—in the United States, in Western Europe, and in Russia. People everywhere have been impressed by her paintings, which so vividly depict life in rural America, the changing seasons, the daily chores and pleasures of farm life, of which the artist was a part for close to a century.

Early Attempts

10. *Fireboard.* 1918. Paper on cardboard, 32¼ x 38¾″

ALTHOUGH ANNA MARY MOSES STARTED PAINTING SERIOUSLY only in her old age, one cannot set an exact date for the beginning of her artistic activities, because, almost without being aware of it, she had from early childhood on done painting and decorating in her home. "When I was quite small," she once wrote,

> my father would get me and my brothers white paper by the sheet, it was used for newspapers. He liked to see us draw pictures, it was a penny a sheet and it lasted longer than candy. My oldest brother loved to draw steam engines, the next brother went in for animals, but as for myself I had to have pictures and the gayer the better. I would draw the picture, then color it with grape juice or berries, anything that was red and pretty in my way of thinking.

But the inclination for painting, shared also by her father and other members of the family, was always subordinated to the duties and obligations of everyday life. Anna Mary did not have the leisure to develop her talent, either in her early youth, as a young housewife in

16

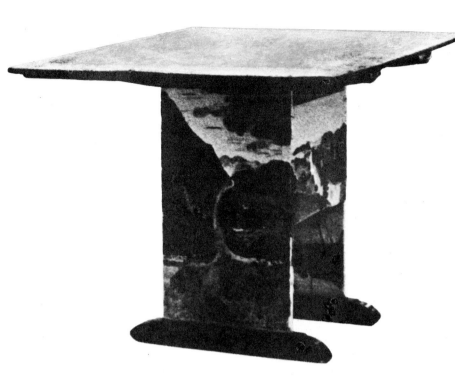

11–15. "Tip-up" table and details. c. 1920.
Collection Mrs. Hugh W. Moses

Virginia, or after the family returned to the State of New York in 1905. But her artistic urge often expressed itself in a desire to decorate objects of daily use around the house. Two examples have been preserved: a fireboard and a table (plates 10–15). She wrote about the fireboard:

> One time I was papering the parlor, and I ran short of paper for the fireboard. So I took a piece of paper and pasted it over the board, and I painted it a solid color first, then I painted two large trees on each side of it, like butternut trees. And back in it I did a little scene of a lake and painted it a yellow color, really bright, as though you were looking off into the sun light. In the front, to fill in that space, I brought in big bushes. I daubed it all on with the brush I painted the floor with. It run on three or four years, and we re-papered the parlor and papered over the picture. When we re-papered the room again a few years ago, we took the paper off the fireboard, but the colors had faded somewhat. That was my first large picture.

About the table she wrote:

> I have an old tip-up table, on which I paint. My aunt gave it to me thirty-five years ago, it was built for a log cabin. . . . The table was made of pine planks, under the top between the stand-ards there was a box in which they kept their pewter dishes. . . . Then one day my aunt sent it to me for a flower stand; I have painted scenes on the standards and covered the top with postal cards, and now use it for my easel.

The painting on the fireboard is dated May 10, 1918, and those on the table were done about 1920. It is interesting to note that these first attempts already show a painterly technique rarely found in works of self-taught artists.

Louis Caldor Discovers
Anna Mary Moses

16. *Mt. Nebo on the Hill.* Embroidery, 10 x 14″. Formerly collection Louis J. Caldor

ONLY IN HER LATE SEVENTIES, when housework became too strenuous for her, did Mrs. Moses start to make pictures that were meant to be framed and hung on the wall. Dorothy Moses, wife of her youngest son, Hugh, who shared the home with her, tells about her mother-in-law's artistic efforts:

> While she was at her daughter's [Anna Moses's] home in Bennington [in the 1930s] she started making yarn pictures, which were very beautiful—as she designed her own pictures and they were done in lovely bright colors. . . . She gave away many and also sold some. . . .
>
> When her sister Celestia called on us one day and saw these

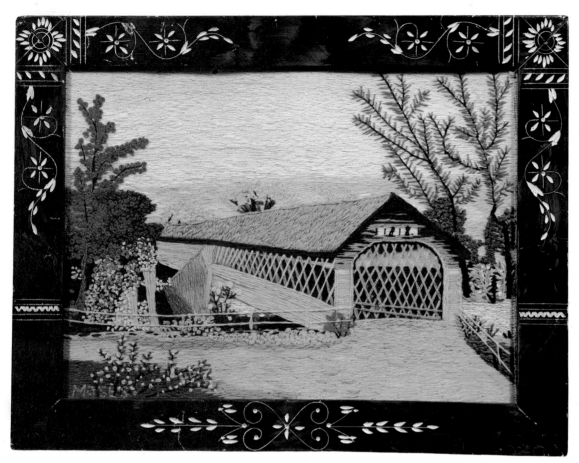

17.
The Old Hoosick Bridge, 1818.
Embroidery, 10 x 14".
Formerly collection Louis J. Caldor

pictures, she told her she should try to paint some—she "knew" she could as long as she could make such beautiful ones in yarn. For her first picture Grandma used a piece of canvas which had been used for mending a threshing machine cover, and some old house paint. We told her it was very good and to try and paint more—which she did. . . .

Some of the first she painted, Hugh and I took along with some yarn pictures down to the Woman's Exchange in Thomas's Drugstore in Hoosick Falls where they were put on display in the window. This is where the ball started rolling for Grandma. One day [Easter 1938] Louis Caldor, an art collector from New York who was passing through Hoosick Falls, stopped at the drugstore and was very much amazed at the wonderful collection. He went in and asked all about the pictures and who the artist was and where she lived. Later he came here and met Grandma. He asked her to paint some pictures for him, which she did, and which he brought to New York. . . .

Louis Caldor made many efforts to interest people in these pictures. He was turned down everywhere. Now and then he was told that the works he showed were quite "nice" but unimportant, and not in line with contemporary art; above all, nobody wanted to waste time and money in promoting an unknown artist who was close to eighty. Caldor had almost given up trying when in 1939 he chanced to hear of plans for a show, "Contemporary Unknown American Painters," to be held in the Members' Rooms of the Museum of Modern Art in New York City. Its organizer was Sidney Janis, a member of the museum's Advisory Board. Caldor went to see Janis, who selected three paintings by Anna Mary Moses.

The exhibition took place from October 18 to November 18, 1939. The three paintings, listed as loans from Louis J. Caldor, were *Home, In the Maple Sugar Days*, and *First Auto* (correct title: *The First Automobile*; see plate 31). Aside from the works by Grandma Moses, the show contained pictures by seventeen other artists: Patsy Santo, Samuel Koch, Ella Southworth, Gregorio Valdes, Morris Hirshfield, Cleo Crawford, Byron Randall, R. J. Bump, Rev. W. S. Mulholland, Hazel Knapp, Fred Fredericks, W. Samet, Alex Fletcher, Bernard Frouchtben, Flora Lewis, Gene Frances, and Dorothy B. Leake.

When the exhibition closed, Louis Caldor's loans were returned to him. About half a year went by after this initial success without Caldor being able to achieve anything more for the artist. However, he remained in touch with her, encouraged her to continue painting, and sent her painting material of more professional quality than she had used in the beginning. He then heard of a new gallery that had recently opened, whose owner was said to be interested in folk art. So Mr. Caldor came to see me for the first time.

First One-Man Show

In the fall of the year 1939 I had opened a branch of my Paris Galerie St. Etienne on Fifty-seventh Street in New York City. In Paris, as well as previously in Vienna, I had mainly concentrated on twentieth-century Expressionist art, but I also had a special liking for folk art and "primitive" painting. I was therefore interested when Caldor offered to show me American folk art that he had collected on business trips through New York State.

Among other objects, he brought pictures which he said had been done by an old woman who lived on a farm in Eagle Bridge, New York, about thirty miles from Albany. These were small pictures, some of them painted, others embroidered in yarn. Their artistic quality varied greatly; some had doubtless been copied from prints and illustrations, but quite a few were very good.

One painting in particular commanded my attention. It was a sugaring-off scene (plate 18). In a snow-covered clearing, people were busy collecting sap from the trees and carrying it in large buckets to a kettle over a fire, children were running around or waiting for the maple candy being prepared by the figure at the left, a sleigh piled with wood for the fire was being unloaded, a team of oxen was approaching—it all added up to a well-balanced scene of animated activity. But what struck me more than this was the way in which the artist had handled the landscape. While the figures were done in a rather clumsy fashion, the landscape was painted with astonishing mastery. Though she had never heard of any rules of perspective, Mrs. Moses had achieved an impression of depth, passing from the tall bare trees in the foreground, the huts and large, clearly outlined groups, to hazy tones in the distance, where smoke rising from the chimney mingled with the bluish gray of an early morning in winter, creating an atmosphere of compelling truth and closeness to nature.

I asked to see more, and Caldor said that he kept a number of pictures in his car, which was parked in Riverdale, a half-hour's drive away. They could only be inspected after 8 P.M., since he worked all day. Eager to get a more definite impression, I agreed to this rather strange way of presenting an artist. We drove out and, the parking lot being unlit, Caldor showed me the pictures by the beam of a flashlight; they were piled up on the back seat of his car.

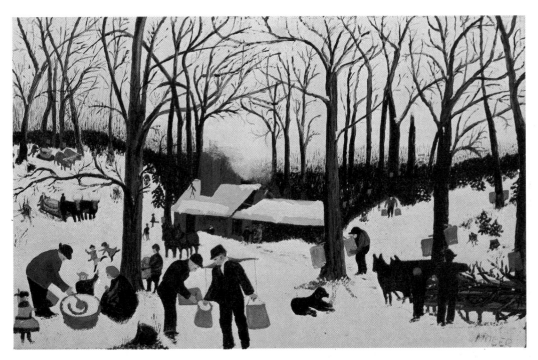

18. *Bringing in the Maple Sugar.* 1939 or earlier. 14 x 23″. Collection Otto Kallir

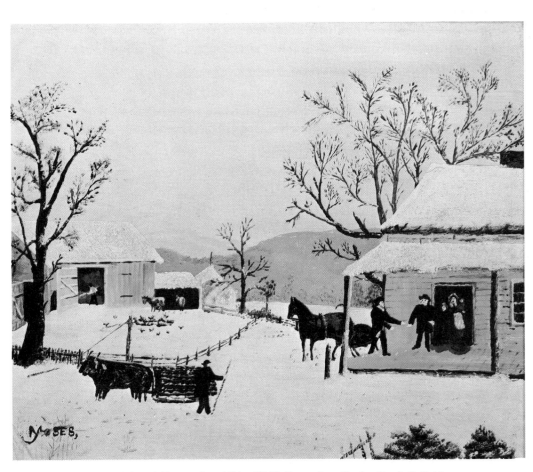

19. *Home for Thanksgiving.* 1940 or earlier. 10½ x 12½″. Formerly collection Louis J. Caldor

Some of the pictures had great artistic quality, others were uninteresting attempts or obvious copies. There were also more yarn pictures, which did not seem to fit in with the rest. Only later did I realize that Mrs. Moses, in her desire to create pictorial scenes, had at first embroidered pictures. The term "picture" meant the same to her whether the scene was embroidered or painted. Still, the positive impression of what I had seen predominated, and I told Mr. Caldor that I would be willing to give the artist a one-man show at my gallery, on condition that the choice of works be left to me.

After the pictures had been assembled at the gallery I was able to examine them at leisure. All were in old frames, either from the Moses attic or from those of neighbors. The size of a painting was determined by the available frame. Most were on cardboard or Masonite, a few on canvas. Grandma Moses later described her way of preparing a picture:

> well I like masonite tempered presd wood. the harder the better,
> I prefer it to canvas, as it will last longer,
> I go over this with linseed oil, then with three coats of flat white paint, now I saw it to fit the Frames.
> A picture with out a fraim is like a woman without a dress. In my way of thinking.

The artist had written a title on the back of almost every picture, usually in pencil. Some, like *Where the Muddy Missouri Rolls,* also bore lengthier inscriptions:

WHERE THE MUDDY MISSOURI ROLL[S] ON TO THE SEA

WHERE MAN IS A MAN, IF HE IS WILLING TO TOIL,

AND THE HUMBLE MAY GATHER THE FRUIT OF THE SOIL.

This was obviously quoted from a poem that had influenced her choice of subject.

Many of the titles Grandma Moses gave her pictures, then and later, indicate what she considered to be the essential content of a painting. In this first show there were such titles as *Apple Pickers* (plate 22), *All Dressed Up for Sunday,* and *The Old Churchyard on Sunday Morning.* Each bespoke the artist's involvement with a given theme. One felt that what she tried to express was always a personal experience, what she depicted was always something she had been part of. Whether the picture was of a washday or a Sunday, it was *her* washday, *her* Sunday.

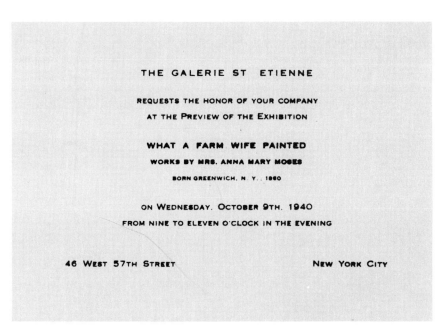

20. Invitation to the first one-man show

21. List of the pictures exhibited

Even when she took material for a picture from a print, magazine, or newspaper, she strove not merely to produce a copy, but to transform the subject into something of her own. For example, she gave her personal touch to a Currier and Ives print, *Home for Thanksgiving;* in color and atmosphere her painting (plate 19, listed as *A Winter Visit* in the first exhibition) far surpasses the print. She had created something fresh and new.

The exhibition opened on October 9, 1940, under the unassuming title "What a Farm Wife Painted." It contained thirty-four small-size pictures, with the exception of two or three that exceeded twenty inches in width. There was no catalogue, but the visitors were given a mimeographed list of the paintings on exhibit.

The general reaction was surprisingly favorable. The simplicity and candor of the pictures, the artist's ability to express in a clear, uncomplicated way what she had to say, established immediate contact between work and beholder. This impression was strongly echoed by

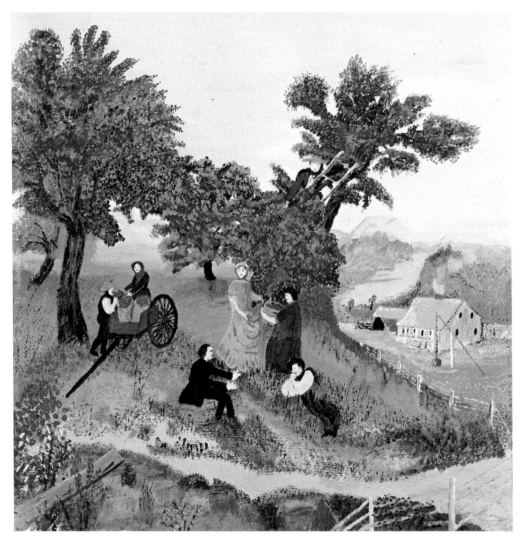

22. *Apple Pickers.* 1940 or earlier. 13 x 12½″. Formerly collection Louis J. Caldor

many newspaper notices; a leaflet containing some of the first reviews was printed at the time and distributed.

We had invited the artist to the opening of the show but she declined, saying she did not need to come since she knew all the pictures anyway.

The name "Grandma Moses" appeared for the first time in an article in the *New York Herald Tribune* of October 8, 1940, which read: "Mrs. Anna Mary Robertson Moses, known to the countryside around Greenwich, New York, as Grandma Moses, began painting three years ago, when she was approaching 80." From then on Anna Mary Robertson Moses became known as Grandma Moses.

Grandma Moses Comes To New York

Shortly before the end of the show at the Galerie St. Etienne, Gimbels Department Store requested the pictures for an exhibition to be held in the store's auditorium for a Thanksgiving Festival on November 14. The exhibition hall was larger than my gallery, so a number of paintings not previously shown, as well as some "worsted" pictures, were added.

Grandma Moses was invited to the festivity, and this time she accepted. She arrived by train, accompanied by Mrs. Carolyn Thomas, the owner of the drugstore in Hoosick Falls where Louis Caldor had found her pictures.

Since 1905, when she had passed through on her way back from Virginia to her native village, she had been in New York only once or twice. The immense changes that had altered every facet of the city were bewildering. After having spent almost eighty years of her life in the country, seldom meeting anyone beyond the realm of her daily life and experience, Grandma Moses was suddenly confronted with several hundred strangers who had come to see her.

Louis Caldor had advised her to take along some homemade bread and preserves. She followed his suggestion and expected to talk about her products, remembering that only a few years earlier, when she had exhibited both her preserves and some paintings at the Cambridge Fair, she had won a prize for her jams while her pictures remained unnoticed.

But now people had come to Gimbels to see her pictures and to meet the artist. She later described her entrance into the hall:

> Someone handed me one of those little old ladies' bouquets and then someone pinned something on me, it felt just like a black bug, but I couldn't look down. It was a microphone, I was on the air. They took me by surprise, I was in from the back woods, and I didn't know what they were up to. So while I thought I was talking to Mrs. Thomas, I spoke to four hundred people at the Thanksgiving Forum in Gimbels' auditorium.
>
> Afterwards, oh it was shake hands, shake, shake, shake—and I wouldn't even know the people now. My, my, it was rush here, rush there, rush every other place—but I suppose I shouldn't say

that, because those people did go to so much bother to make my visit pleasant.

The following day Grandma Moses, accompanied by Mrs. Thomas, came to see me at my gallery. It was our first meeting. As far as I remember, we talked about her trip and her impressions of the city, hardly at all about her painting. Shortly afterward she returned to Eagle Bridge. At that time I did not in the least expect that within a few years a close cooperation in all matters concerning her artistic work would develop between us, as well as a warm and enduring personal friendship.

The public's reaction to the larger display of Grandma Moses's pictures at Gimbels was an interesting indication of future trends. While many judged them with kindly condescension, there were also those who, even though favoring contemporary modern art forms, recognized her work as a valid artistic expression.

In January 1941, the exhibition was sent to the Whyte Gallery in Washington, D.C., where it was received with even more favorable comment than in New York. The artist had come to the attention of the public.

23.
Grandma Moses and Carolyn Thomas
at Gimbels Auditorium,
November 14, 1940

New York State Prize

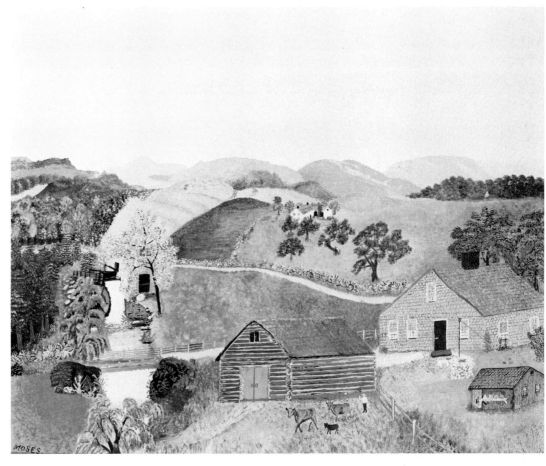

24.
Old Oaken Bucket.
1941. 25 x 31".
Collection John N. Irwin II

DURING THE INTERVAL BETWEEN HER FIRST SHOW IN NEW YORK in October 1940 and an exhibition at the Syracuse Museum of Fine Arts (now the Everson Museum of Art) in May 1941, Grandma Moses had gained considerable assurance. She now ventured into larger-size pictures, and their composition was on a broader, freer scale. One of these new paintings was *Old Oaken Bucket* (plate 24), which illustrates a popular song she had learned in her youth. Explaining how she came to paint it, she wrote:

> That winter I had the grippe, and they kept me in bed, and I planned mischief then. When I was lying there, I thought I was going to paint the story of the "Old Oaken Bucket," because I knew how it originated. I painted it when I got up, that was the

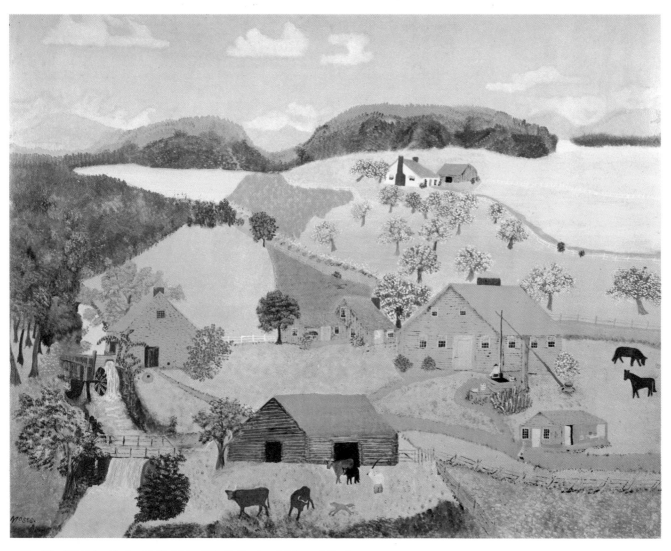

25. *The Old Oaken Bucket.* 1943. 23½ x 30″. Collection Hildegard Bachert

first one I tried, but later I painted it again and could remember more of the details.

Then I was requested to send several pictures out to the gallery in Syracuse, where they had an exhibition. I sent the "Old Oaken Bucket," the "Checkered House," and a picture with a young colt in it. Hugh and Dorothy persuaded me to attend the show, so we went to Syracuse. My picture, "The Old Oaken Bucket," took the New York State Prize, and Mr. Thomas J. Watson bought it.

Artistic Progress

A ONE-MAN SHOW THE FOLLOWING YEAR should be mentioned. It was held from December 8 to December 22, 1942, at the American-British Art Center in New York, whose director, Ala Story, had begun to take an interest in the artist. Thirty-two paintings were on display, among them one listed in the catalogue as *Black Horses* (plates 26, 27; Grandma Moses herself had titled this picture *Lower Cambridge Valley*). The quality of the painting so impressed me that I consider it the turning point in my evaluation of the artist.

If up to that time I had looked upon Grandma Moses's work as interesting and appealing folk art, I suddenly realized that here was an outstanding painter. Her progress within two short years was astonishing. Whereas the early pictures are for the most part small, the figures often cramped in little surrounding space and the colors of the landscapes without much range, in *Black Horses* a new conception seems to have emerged, as though the artist's eyes had been opened to broad vistas of nature.

There was the view of the Cambridge Valley and the panorama of the distant mountain range and, above all, there was the subtle blending of muted colors. Forests, meadows, hills, and fields planted with a variety of crops were all painted in their own appropriate tones, yet formed a harmoniously integrated whole. To keep the picture from being a mere landscape, Grandma Moses had "brought in" (as she would say) two cantering black horses in the lower right foreground which attract the beholder's attention. A brown horse, with two children astride, stands docilely on the left, counterbalancing the other group. The artist later noted that the black horses had belonged to her great-grandfather and that one of them was killed in the Battle of Walloomsac during the Revolutionary War.

In the following years Grandma Moses created many new paintings that confirmed the fact of her development. In most of her early work she had represented single objects, such as a covered bridge, an old mill, a waterfall, an ancient car. The subject itself was all-important and the artist used the landscape as a setting; she did not as yet possess the ability she was soon to acquire to create a landscape which would not merely serve as surrounding scenery.

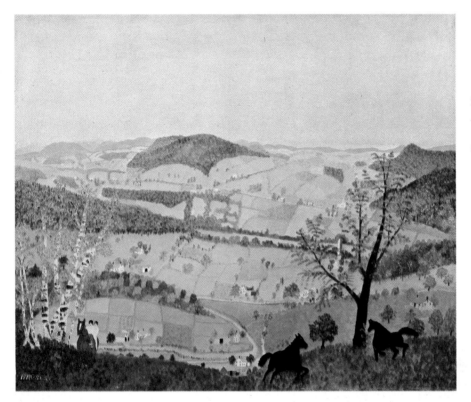

26.
Black Horses.
1942. 20 x 24″.
Collection Otto Kallir

This development can be traced by comparing early and later versions of the same theme. One of the pictures included in the first exhibition was *The Burning of Troy* (plate 29), done in about 1939. It shows a covered bridge on fire. The idea for this painting derived from an illustration and story (plate 28) Mrs. Moses had cut out of a Troy, New York, newspaper, which "77 years later" recalled the catastrophe of Saturday, May 10, 1862. By a few pencil lines on the clipping she had indicated how she intended to change the oval illustration into a rectangular painting. More important, her imagination transformed the black-and-white newspaper print into a dramatic scene of flaming reds and dark billowing clouds of smoke, harsher and cruder colors than she would use in later years but forcefully evocative of the terrible event. This first version makes use of most of the elements shown in the newspaper illustration: the horse and cart looming very large in the foreground, the figures of running men carrying buckets darkly outlined against the flaming interior of the bridge, the brick structure supporting the bridge, and even a small boat tied to a post at the river's edge. The representation of the subject is all that matters, the bridge itself filling the entire width of the picture, flames and smoke reaching up to the top, leaving just enough space at the sides to indicate the approaches to the bridge and the river it spans.

27. *Black Horses* (detail) ▶

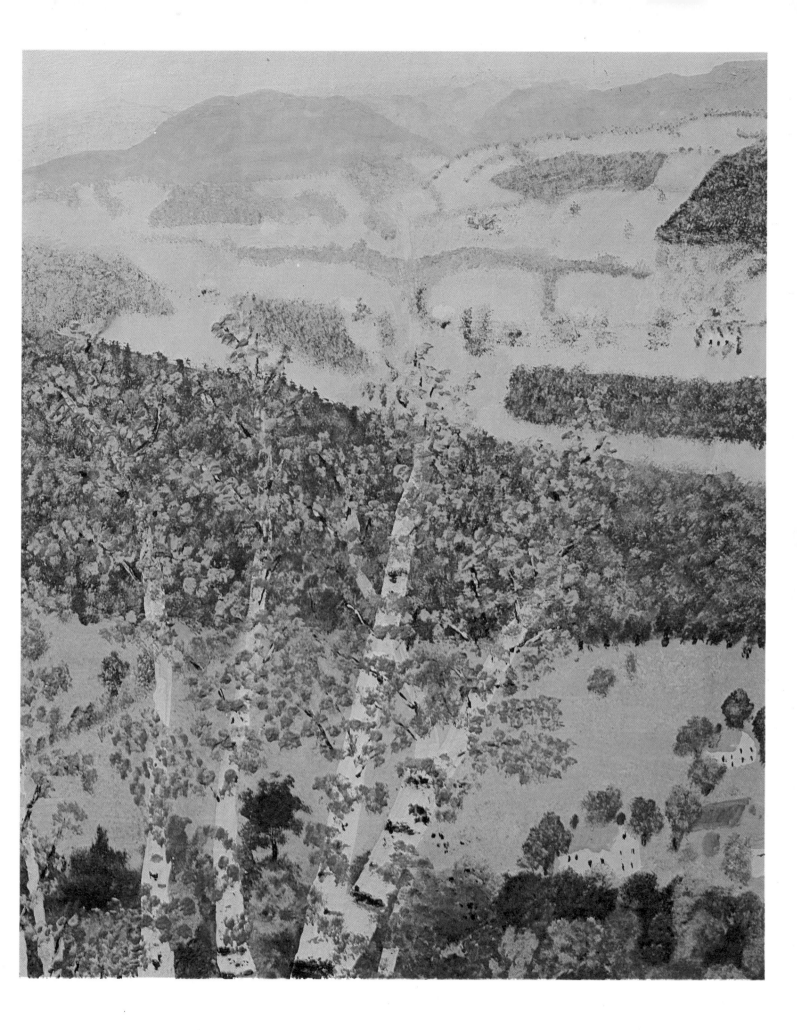

In 1943 the artist used the same theme for a large painting titled *The Burning of Troy in 1862* (plate 30). But it shows an entirely different mood, less dramatic, more picturesque. It is now a wide landscape, serene in spite of the burning bridge that dominates the center of the painting. The hurrying figures and the horse and buggy have become less prominent. There is a cluster of charming houses and trees on the far river bank, apparently removed from danger. To the left of the bridge the river flows quietly through a hilly countryside painted in soft hues, the sky is high and clear above the burning bridge, and on the right a willow tree is delicately outlined against the river. Distant hills melt into the pale blue of the horizon.

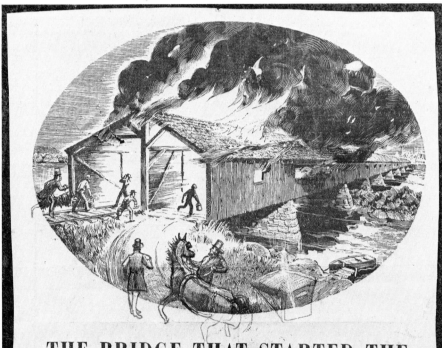

THE BRIDGE THAT STARTED THE GREAT FIRE OF 1862

A COW started the great fire of Chicago. An earthquake started the great fire of San Francisco. But Troy's Great Fire was started by an old covered bridge.

From New York Bay to the head of navigation at Waterford, it was the first bridge ever built across the Hudson. Nearly a third of a mile long, it was wide enough to accommodate a railroad track, a carriage road, and a footway.

On Saturday, May 10, 1862, it nearly destroyed the city of Troy. A gale was blowing from the northwest, when a spark from a locomotive lodged in the shingles on the roof. In a twinkling, the entire bridge was in flames and the wind had carried burning embers to all parts of the city.

The fire started at noon. By six o'clock in the evening, seventy-five acres in the heart of Troy had been "swept over as by the hand of a destroying fiend." "Tears and despondency," says a historian, "could not recall the burned property which had been slowly accumulated by the incessant industry of many years." But by the latter part of July, 181 buildings had been rebuilt, and by November, all but a few of the burned lots were covered with new and superior structures. Once again, the famous "enterprise of the Trojans" had not failed. And this bank is proud to have played a part in rebuilding the stricken city. Today, 77 years later, the Manufacturers National joins with other Troy banks in looking forward to a great industrial and commercial future.

28.
Newspaper clipping of 1939 about the Great Fire of 1862

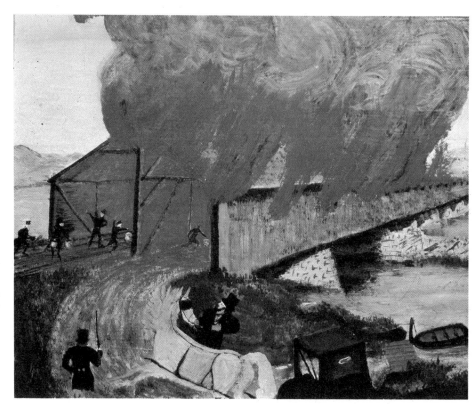

29.
The Burning of Troy.
c. 1939. 9 x 11¼″.
Formerly collection Louis J. Caldor

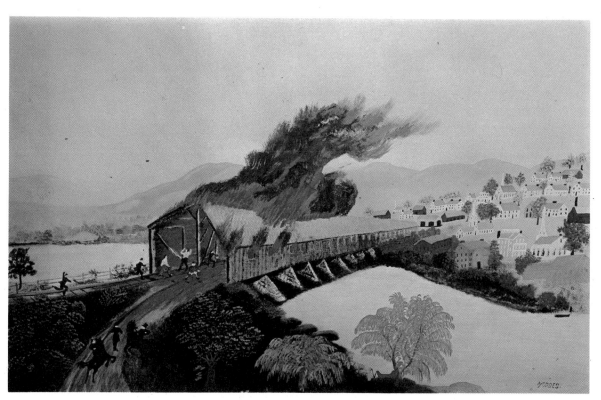

30.
The Burning of Troy in 1862.
1943. 19 x 30″

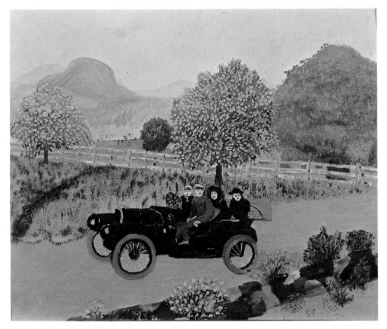

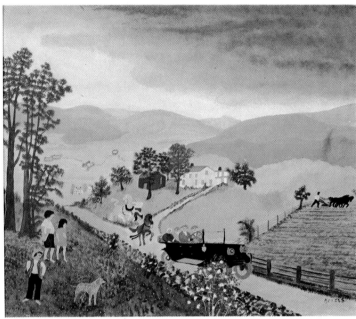

31. *The First Automobile.* 1939 or earlier. 9¾ x 11½".
Formerly collection Louis J. Caldor

32. *Automobile, 1913.* 1943. 17¾ x 21¼".
Formerly collection Artur Schnabel

There are several more versions of this subject, the last one—a small picture—painted in 1959. Grandma Moses had kept the clipping from the Troy newspaper all that time.

Three other paintings, each to my knowledge an original composition, also demonstrate the artist's progress: *The First Automobile* (1939 or earlier), *Automobile 1913* (1943), and *The Old Automobile* (1944) (plates 31–33). In the earliest, the clumsy car takes up the greater part of the foreground, framed by a sketchy landscape dominated by two trees in bloom. In the second version, *Automobile 1913,* the landscape predominates. In the center foreground there is again an open car with four people in it, as clumsy as the previous one. It evidently had been put in after the landscape was completed. Its motion and noise are indicated by two shying horses. Three children watch the unfamiliar sight, a farmer plows his field, a tree-shaded house with barn and small cottages are scattered in the valley. A dark sky over distant hills gives the picture a somewhat somber aspect.

One year later Grandma Moses took up the subject for a third time. Now the old car, though again placed in the center of the foreground, has become incidental in a delicately painted landscape; the hues of

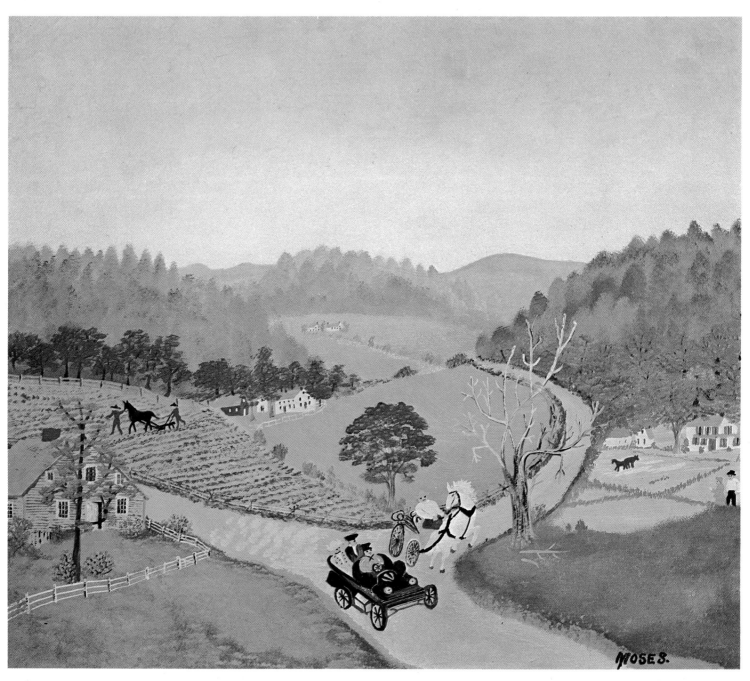

33. *The Old Automobile.* 1944. 18¾ x 21½''. Private collection

the forests fade into ever softer greens toward the background, and the coloring of the hills conveys an impression of great distance. Everything is quiet and at peace; it could be a scene of a hundred years ago, were it not for the newfangled contraption before whose rattling and speed, filling the air with visible dust clouds, the horse in front of a buggy rears in terror.

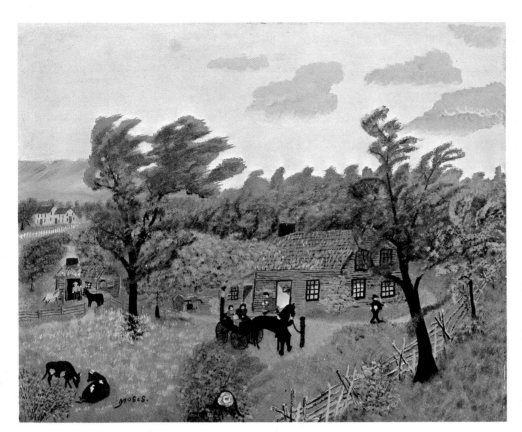

34.
The Hitching Post.
1948. 15 x 19¼".
Private collection

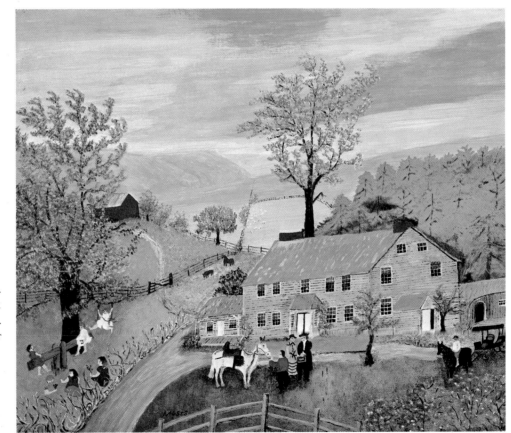

35.
The Doctor.
1950. 20 x 24".
Collection Otto Kallir

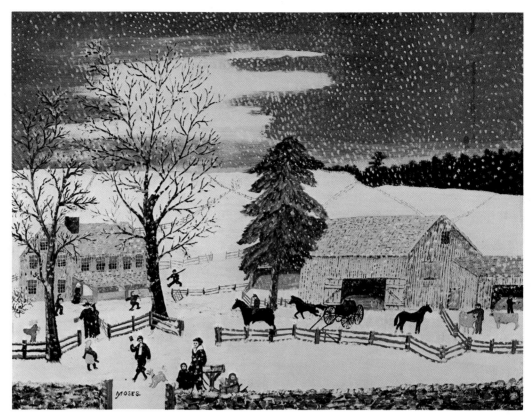

36.
The Mailman Has Gone.
1949. 16¾ x 21½″.
The Shelburne Museum,
Shelburne, Vt.

Grandma Moses often chose to title a picture for a detail quite subordinate to the general composition. In *The Hitching Post* (plate 34), for instance, two windblown trees dominate the scene, rather than the horse-and-buggy being tied to the hitching post that gives the picture its name.

The title of a charming summer landscape with trees and meadows and children playing out of doors is *The Doctor* (plate 35). A man and a woman are standing in front of a large house; evidently the doctor has just arrived on horseback and is talking to the lady of the house who has come out to meet him.

A very dramatic landscape with falling snow and a dark, stormy sky bears the title *The Mailman Has Gone* (plate 36). There is a roadside mailbox, and among a number of people a man is proudly holding up a perhaps long awaited letter.

The narrative content has become part of an all-over visual impression. The fluid technique, far removed from that of a "primitive," can be traced even in Grandma Moses's earliest pictures; she rapidly gained assurance and mastery as her work progressed.

After the 1942 exhibition at the American British Art Center and others at various galleries in the following years, the work of Grandma Moses became widely known. As a result, she received many letters from people who wrote that they liked a certain painting they had seen and wanted her to "paint just such a picture" for them. Among the themes most in demand were Over the River to Grandma's House, The Old Oaken Bucket, Catching the Turkey, The Checkered House, and Sugaring Off. Although Grandma Moses did not enjoy these "orders," she obliged, because, as she said, she did not want to disappoint her friends. This explains the frequent recurrence of these titles.

It is interesting to note, however, that the artist hardly ever copied her paintings exactly. She found ways to vary the composition of a given theme, now as a winter scene, now as a spring, summer, or fall landscape. This gave her the means to change the atmosphere and tone of a painting.

If one calls to mind how many artists have simply copied their successful paintings upon order, one can only admire how this untaught woman avoided repeating her own work. What she did retain in each variant were the characteristics of any specific theme.

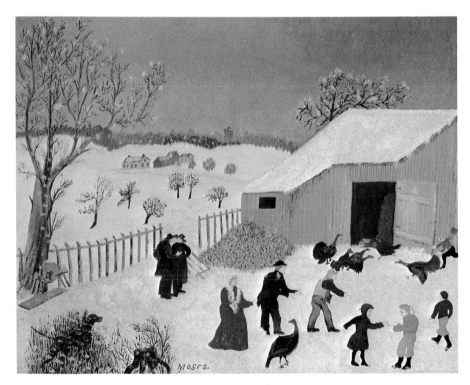

37.
Thanksgiving Turkey.
1943. 16 x 20".
The Metropolitan Museum of Art, New York.
Bequest of Mary Stillman Harkness, 1950

38.
Checkered House.
1943. Canvas, 36 x 45".
IBM Corporation, Armonk, N.Y.

39.
Checkered House.
1955. 18 x 24"

The *Checkered House* (plates 38, 39), for example, always shows a large building with a red-and-white checkerboard design, barns and sheds, a wide road in the foreground alive with horses pulling carriages, riders on horseback, and men in uniform. In her youth she had seen this building, which was a landmark near Cambridge, New York. Later she wrote about it: "The Checkered House is old. . . . It was the Headquarters of General Baum in the revolution war, and afterwards he used it as a Hospital, then it was a stopping place for the stage, where they changed horses every two miles, oh we traveled *fast* in those days."

Looking at two variations of the *Checkered House,* I once asked her how she managed to represent the same motif in a fresh form. She said that she visualized the picture she was about to paint as though framed in her window and that she had only to imagine she was looking out on the scene either from the right or from the left and that accordingly all parts of a composition would shift into place.

The figures that populate her landscapes are for the most part "types" who perform certain standard chores: the men carrying wooden buckets in "sugaring off" pictures, for instance (plate 40), or the ones catching the turkey (plates 37, 42). Sometimes there are soldiers in old uniforms, indicating a historical setting (plates 38, 39).

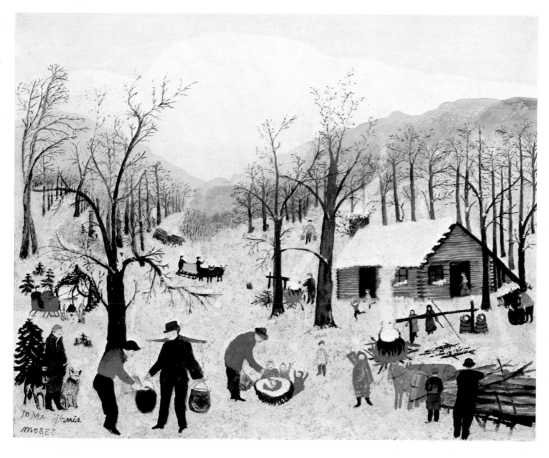

40.
Sugaring Off in Maple Orchard.
1940. Canvas, 18⅛ x 24⅛".
Private collection

41. *Sugaring Off in Maple Orchard* (detail) ▶

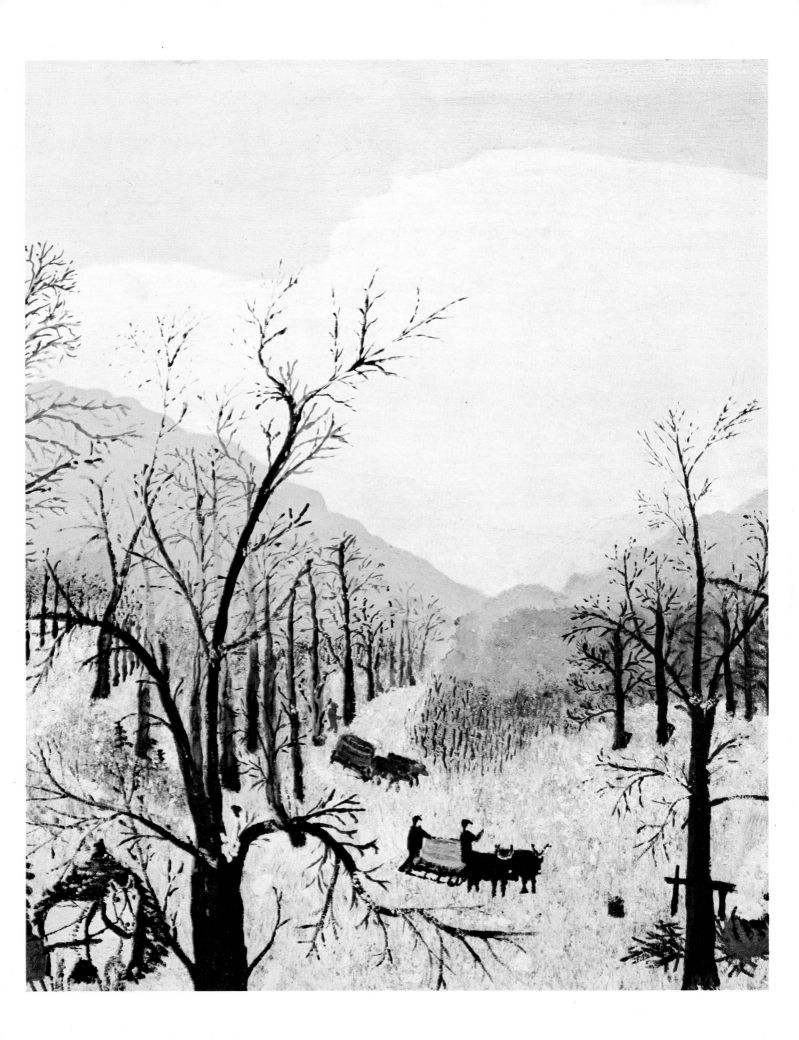

Such figures were often taken from books or old prints, or from the newspaper clippings which she kept in a box. This helps to explain their recurrence in Grandma Moses's paintings, whereas the landscape is always the original artistic expression of her own vision. Remarkably enough, the animals in her pictures are seldom stereotyped in the way that her human figures are. Rarely did she copy them; they are painted with natural ease and abandon, with the emphasis not on details of their appearance but on their movements, which are astonishingly well observed. One need only study the horses in her paintings (see plate 119): in the winter pictures some of them trot heavily through the snow, straining to draw a laden sleigh; others are unburdened and light in their movements or even try to break out. This seemingly effortless touch, achieved also in the landscapes, was not at her disposal in the human figure.

The blending of two distinct components—sensitively felt and beautifully represented nature scenes, painted in an almost Impressionist manner, with primitive though often colorful human figures—into artistic harmony constitutes what has become known and recognized the world over as the Grandma Moses style.

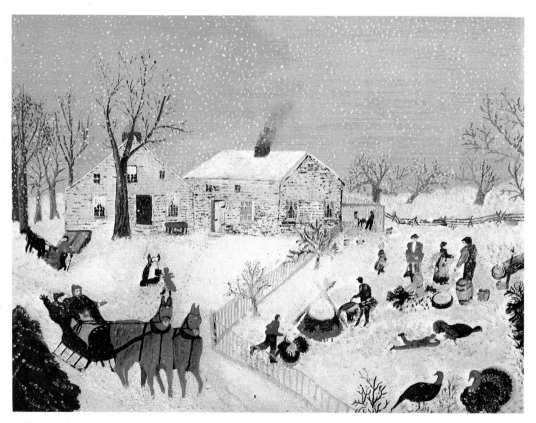

42. *Catching the Turkey.* 1940. 12 x 16″. Formerly collection Louis J. Caldor

The Early Years to 1946

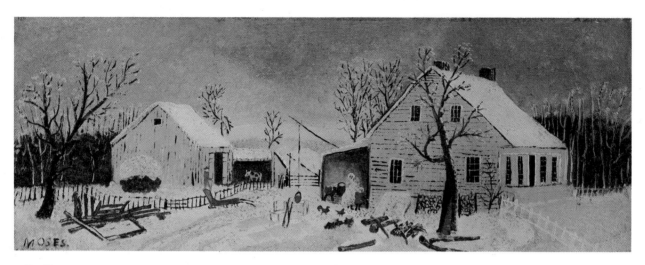

43. *Home in Winter.* c. 1938. 6 x 16″. Galerie St. Etienne, New York

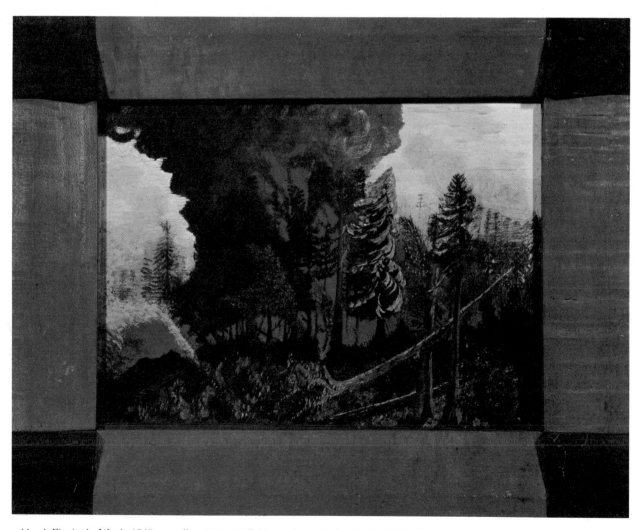

44. *A Fire in the Woods.* 1940 or earlier. 10¼ x 15″. Formerly collection Louis J. Caldor

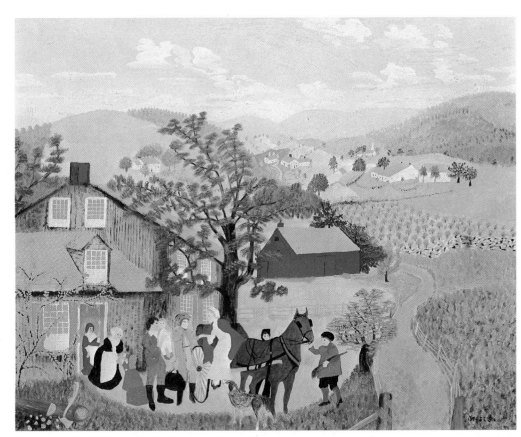

45.
The Daughter's Homecoming.
1943. 19¾ x 23½"

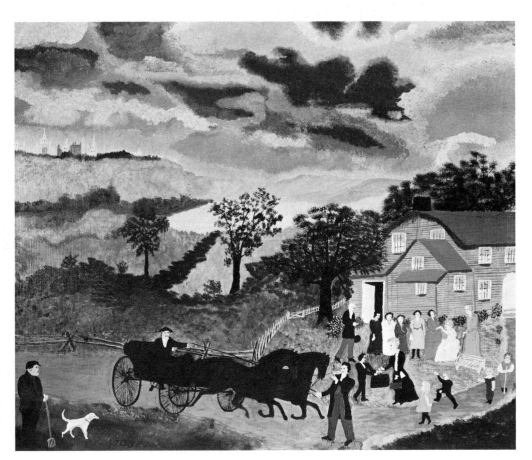

46.
Grandma Going to the Big City.
1943. 21 x 24".
Sidney Janis Gallery, New York

47. *Home of Hezekiah King in 1800, No. 4.* 1943. 23 x 29″

48. *Mt. Nebo in Winter.* 1943. 20½ x 26½″. Private collection

49. *The Sun Has Gone Down.* 1944. 6 x 9″. Private collection

50.
In Harvest Time.
1944. 12 x 17″

51. *Out for the Christmas Trees.* 1944. 24 x 29½".
Collection Anson Brooks

52.
The Lookout, 1777, Vermont. 1945. 17 x 21".
Formerly collection Bernard M. Douglas

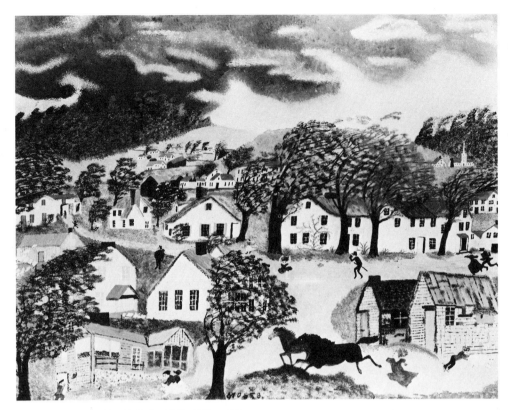

53. *Hurricane in Hoosick Falls.* 1945. 15¾ x 20″

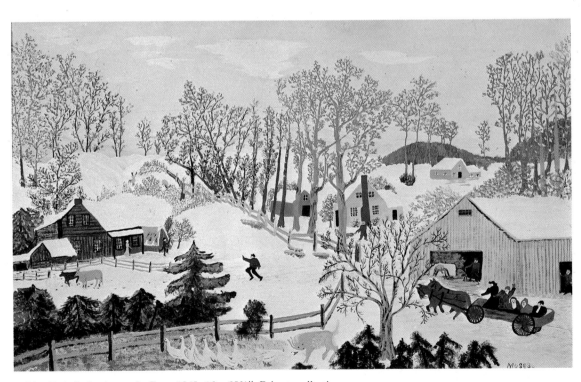

54. *Early Springtime on the Farm.* 1945. 16 x 25¾″. Private collection

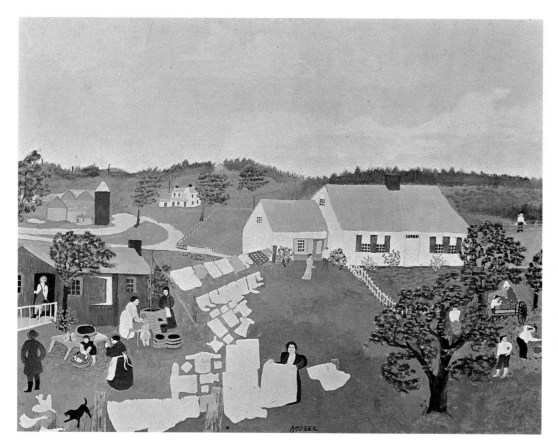

55.
Wash Day.
1945. 17¾ x 23½".
Museum of Art,
Rhode Island School of Design,
Providence

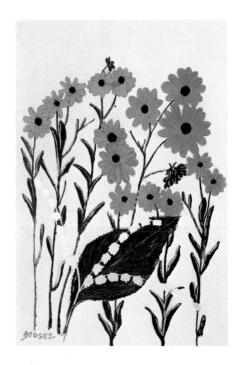

FAR LEFT:
56.
Wild Roses.
1945. 10¾ x 9¼".
Private collection

LEFT:
57.
Wild Daisies.
1945. 11¾ x 7¾".
Private collection

2

GROWING RECOGNITION

"Grandma Moses: American Primitive"

HAVING REALIZED HER IMPORTANCE AS AN ARTIST and witnessed the public's growing interest, I decided, in 1945, to write a book on Grandma Moses. I had often visited her at her home in Eagle Bridge and we naturally discussed the project. From our many conversations and even more from her letters, I found, to my delight, that her ability to express herself was not limited to painting. She had a most vivid and personal style, as well as a spelling all her own. It was fascinating to listen when she told stories of her family and of events she had witnessed or been told about in her youth, some of historical interest, others just local anecdotes.

Feeling that here was a rich source of first-hand information about rural life in nineteenth-century America, I encouraged Grandma to write down what came to her mind whenever she felt like doing so. In the course of a year she sent me three autobiographical sketches, one of which is reproduced in facsimile at the beginning of the present volume. She sent along a letter, saying in her modest way: "Here is my life's history, can you make anything out of it? . . . You see, I don't know how to go about such things."

She also agreed to write comments on the forty paintings to be reproduced in the book. They were not only descriptions of the pictures, but also stories about the depicted events. Everything was written in her own clear and meticulous hand and was so charming and original that I decided to have the comments reproduced in facsimile opposite each illustration.

The book was published in 1946 (Dryden Press) under the title *Grandma Moses: American Primitive*. Louis Bromfield, who had been interested in the artist for a number of years, wrote the introduction. The book proved an immediate success, and was republished in 1947 (Doubleday) with additional colorplates. Widely reviewed in the American press and in some European papers, it drew increased attention to Grandma Moses. Museums and art centers the country over asked to present her work.

Reproductions and Christmas Cards

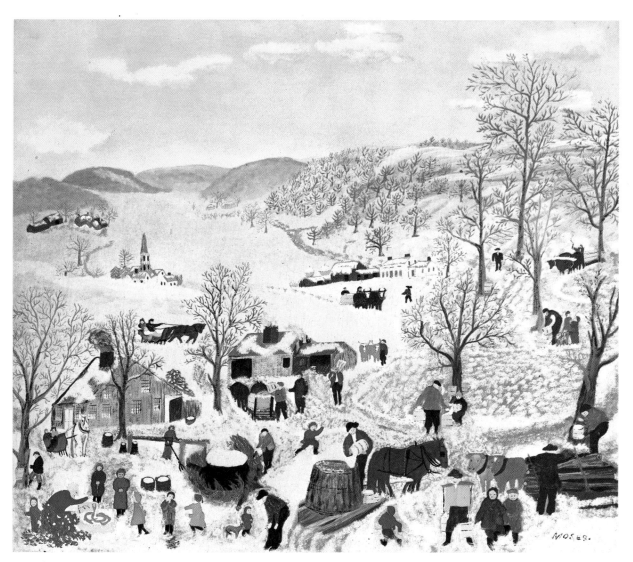

58. *Sugaring Off.* 1943. 23 x 27". Private collection. First color reproduction, 1948

GRANDMA MOSES HAD NEVER HAD THE IDEA of selling her paintings for high prices; still less would the thought have entered her mind that she might receive money from reproductions of her pictures. She had always been a conscientious and thrifty housekeeper and she could not understand why she should get more for a painting than she had asked; it seemed to her almost an offense. I had already become familiar with this attitude in the course of the first exhibition. Two or three of her works had been sold for a substantially higher sum than what Louis Caldor had paid her. Not having met Mrs. Moses personally at the

time, I suggested to Caldor that she be sent an additional amount. No sooner had the check been mailed than it was returned by Mrs. Moses with the remark that everything had been paid for, she was not owed anything, and she did not want the money.

Later on I once sent her twenty dollars above the price she had indicated for a picture. She kept it this time but wrote: "In regard to paying for paintings you do not have to pay more then I ask." (October 3, 1945) On a previous occasion she had written: "Don't pay me in advance as it puts me under obligation, and that I don't want now. Ive got to that age where I want to keep my House in order." (September 15, 1943)

Soon after the first exhibitions, requests came to reproduce Moses paintings. In order to protect them from unauthorized use, all her pictures were registered at the Copyright Office in Washington. Large, excellent-quality color reproductions of her important pictures were printed (plate 58) which could be afforded by wide circles and contribute to making the artist's work known.

Christmas and greeting cards also helped to spread her popularity. The firm of Brundage Greeting Cards published the first set of sixteen Grandma Moses Christmas cards in 1946. Then, in 1947, Hallmark acquired the right to reproduce the artist's paintings on Christmas and greeting cards and published them for many years.

When Grandma Moses received a large sum of money in royalties from the first Christmas card venture in 1946, she was at a loss to understand how she came to get it, and she did not cash the check. Visiting her some time later, I inquired why she had not done so, whereupon she produced it and seemed puzzled. I tried to explain that some of the paintings she had sold were earning all this money for her by being reproduced on Christmas cards and that she was participating in what they brought. She shook her head but promised to follow my suggestion and take the check to the bank in Hoosick Falls. The next day, the cash was lying in bundles on the table, and she said she had kept her word.

Seeing that Grandma Moses was not able to cope with such business matters, it was decided to have a lawyer take care of her financial affairs. Starting in 1947, all receipts from the sale of paintings and all royalties derived from copyrights went to Sylvester Scott of Hoosick Falls; he was a longtime friend, personally interested in the artist's work, and he administered her income almost up to the time of her death.

Documentary Film

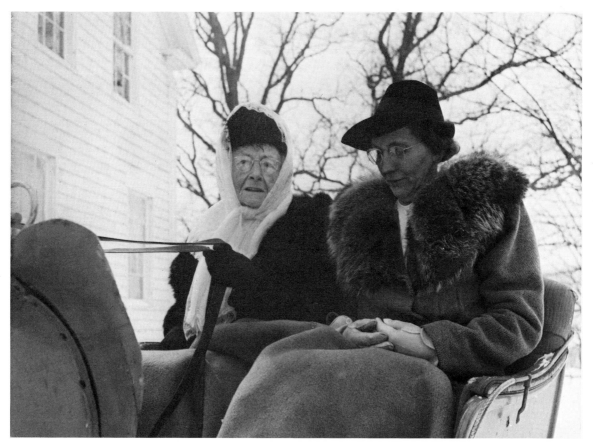

59. Grandma Moses with her daughter-in-law, Dorothy, during making of documentary film. Photo by Erica Anderson

ALA STORY, WHO SHARED MY CONVICTION of the artist's importance, had been working closely with me since 1945—our association lasted many years. In 1946 we began making plans for a film on Grandma Moses. Erica Anderson, who was to gain fame with her movie on Albert Schweitzer, went up to Eagle Bridge from time to time and took color pictures of the artist, her home, her family, the setting of her daily life, and the surrounding countryside. They were as yet disconnected color shots with no guiding script. The motion picture producer Jerome Hill then arranged the material to form a documentary, which was completed in 1950. Archibald MacLeish wrote and narrated the text; the music was composed by Hugh Martin and arranged by Alec Wilder. The film received the "Certificate of Nomination for Award" from the Academy of Motion Picture Arts and Sciences.

Visit to Washington

In May 1949, Grandma Moses was invited to go to Washington, D.C., to receive the Women's National Press Club Award. The President of the United States was to present "certificates of achievement" to six women who were being honored "for their outstanding contributions to their respective fields for the year 1948."

Grandma Moses left her home in Eagle Bridge on May 12 in the company of her daughter-in-law Dorothy. They arrived in New York by train. A wheelchair had been prepared at the station to take Grandma to a taxi. "That was humiliating to me, but I couldn't have walked it," she later wrote. She and Dorothy spent two nights at our home in New York.

The press wished to meet her, so I arranged a small exhibition of the artist's paintings at my gallery.

The next day the *New York Herald Tribune* wrote:

> There was a host of reporters, photographers and radio people in the room when Grandma walked in. . . . After surviving the ordeal by flash bulbs she moved over to a sofa, where she faced a solid ring of reporters with a devil-may-care attitude. . . . The questions came thick and fast and mixed up. She not only displayed the utter independence of the elderly but it was evident that she was having the reporters on a bit. . . . When asked if she was excited at the prospect of seeing President Truman and Mrs. Franklin D. Roosevelt, who also is receiving the award, she said, "No. Not at all." . . . Somebody asked if she wanted to paint the New York City scene.
>
> "It doesn't appeal to me," she said.
>
> "You mean it doesn't appeal to you as painting material?" someone asked.
>
> "As any material," said Grandma crisply.
>
> With characteristic understatement she called her painting a pleasant occupation. "As I finish each picture, I think I've done my last, but I go right on," she said.

On the evening of May 14 the official dinner took place in the Presidential Room of the Statler Hotel in Washington. Seven hundred guests attended, among them the diplomatic corps, the

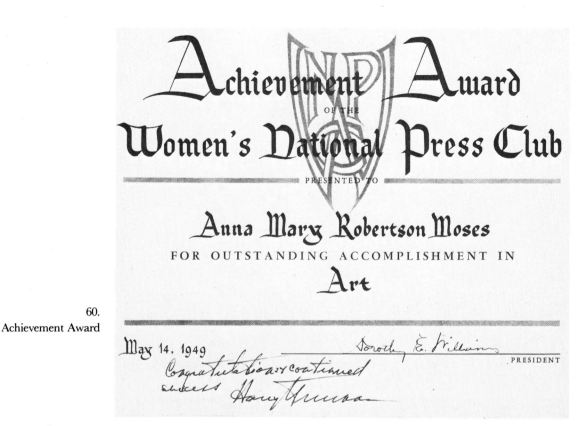

Supreme Court Justices, and the members of the President's Cabinet with their wives. When Grandma Moses entered the hall, she received a big ovation, which she smilingly acknowledged without interrupting her progress toward the dais, where she was seated next to Mrs. Truman. The President handed her the award "for outstanding accomplishment in Art," which he had inscribed for her.

The other recipients were: Mrs. Franklin D. Roosevelt for her work as Chairman of the United Nations Human Rights Commission; Mary Jane Ward, author of *The Snake Pit*, a novel which focused attention on the need for improving mental institutions; Madeleine Carroll for outstanding achievement in the theater; Dorothy McCullough Lee, the first woman to be elected mayor of a city exceeding 500,000 (Portland, Oregon); and Marjorie Child Husted, of General Mills, Inc., for achievement in business.

During the dinner Grandma Moses carried on a lively conversation with the President and his wife. He told me afterward how charmed and impressed he was by her and added that he would very much like to see her again and that therefore, if at all possible, he would attend a tea to which the award recipients had been invited by Mrs. Truman the following day.

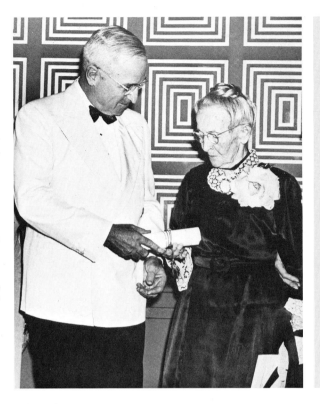

61.
Grandma Moses receiving
the Women's National
Press Club Award from
President Harry S Truman,
May 14, 1949

62. Letter from President Truman
to Grandma Moses, May 26, 1949

When we arrived at Blair House, where the Trumans were living while the White House was being remodeled, the President was already there and he again chatted with Mrs. Moses. "After the tea," Grandma recalled, "we had a terrific thunderstorm, so we sat down on a couch to wait till the shower was over. President Truman sat beside me and said, 'Don't be afraid, as this is a large building with many lightning rods on it.' Maybe he thought Grandma might be afraid. I talked with him, and I could not think but that he was one of my own boys. I even asked him to play something on the piano." At first he was reluctant and suggested he would turn on the radio instead, but Mrs. Moses insisted, so he smilingly went to the piano and played a minuet by Paderewsky. "That was a delight," she wrote. "Then the shower was over, and he ordered his own car to take us to the Hotel Statler, that was an honor."

Next day Grandma Moses visited the Phillips Gallery, where a large loan exhibition of her paintings had been arranged. In 1941 Mr. and Mrs. Duncan Phillips had been the first to acquire a Grandma Moses picture for an American museum; they subsequently added several more to their collection (see plate 142).

When Grandma Moses and Dorothy returned home on May 20, "her many friends, neighbors and relatives in Eagle Bridge were joined by

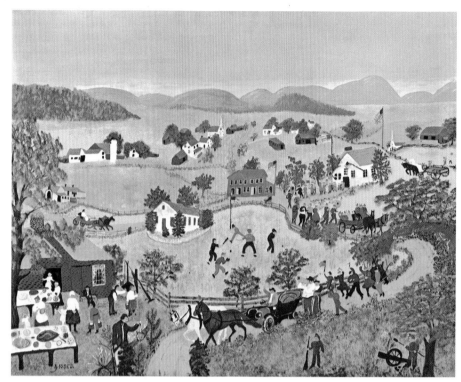

63.
July Fourth.
1951. 23⅞ x 30″.
The White House, Washington, D.C.

folks from all over Rensselaer County who came to welcome Mrs. Moses. . . . Several hundred automobiles jammed the village's only street, as an estimated 800 persons—almost twice the population of Eagle Bridge—assembled at the World War II Honor Roll in the center of the little community. . . . She was back home again after receiving the largest welcome the small village could give. . . ." (*Troy Record,* May 21, 1949) School children sang and presented her with flowers. The Hoosick Falls High School band played and escorted her all the way home.

Perhaps of the honors she had received, she enjoyed most the welcome she got in Eagle Bridge. "In a way I was glad to get back and go to bed that night," she wrote later.

When President and Mrs. Truman moved into the remodeled White House, I wrote to Mrs. Truman on March 21, 1952: "As I have seen in the papers, the White House will be reopened on April lst. It would be a great pleasure to me to dedicate on this occasion an original painting by Grandma Moses to the White House and to the American people, if the President and you would approve of my intention, and if there is a place for it." My suggestion was accepted, and *July Fourth* (plate 63), which the artist had painted in August 1951, has been hanging at the White House ever since.

Moving to a New House

64. Grandma Moses's old house, Eagle Bridge, N.Y.

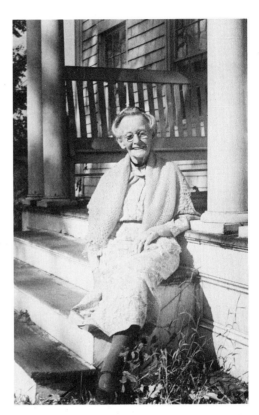

65. Grandma Moses on the front-porch steps of the old house, c. 1946

GRANDMA MOSES WAS NOT TO STAY MUCH LONGER in the old farmhouse, although she referred to it as "home" for the rest of her life. Her youngest son, Hugh, who had taken care of the Moses farm, had died suddenly in February 1949. Grandma stayed on with her daughter-in-law Dorothy, but her two surviving sons, Forrest and Loyd, were building a more comfortable ranch-style house for her across the road. She moved into it in April 1951. Her daughter, Winona Fisher, came from California to care for her and eventually took over more and more of the tasks that Grandma had been doing herself, such as letter writing, making entries in the Record Book, and sometimes writing labels for pictures. Aside from seeing to it that her mother was comfortable, Mrs. Fisher had a keen understanding of her significance as an artist and as a personality. After Mrs. Fisher's death in 1958, Forrest Moses and his wife Mary moved in with Grandma and took care of her.

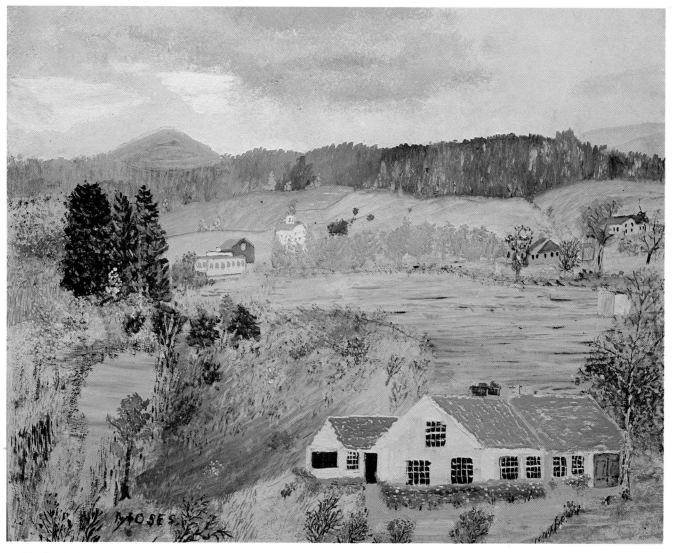

66. *Grandpa's House.* 1951. 9¼ x 12″. Private collection. This picture shows the house to which the artist moved in April 1951.
It was built by Forrest Moses, who was often called "Grandpa"

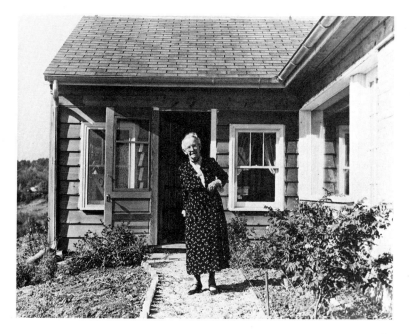

67.
Grandma Moses in front of
the new house, 1952

First European Exhibitions

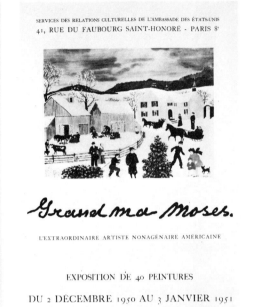

68–70. Posters of the first Moses exhibition to travel in Europe

SHORTLY AFTER WORLD WAR II, European papers and magazines had begun to take notice of Grandma Moses. Many articles, frequently accompanied by illustrations, were published on the story of Anna Mary Robertson Moses and on the attention her work was receiving in the United States. A desire to see the original paintings was repeatedly expressed, and in 1950 a collection of fifty pictures was assembled and sent to Europe under the sponsorship of United States Information Centers or embassies. The exhibition was shown in Vienna, Munich, Salzburg, Berne, The Hague, and Paris. While the initial reaction to the "Grandma Moses phenomenon" had been one of skepticism, a first-hand acquaintance with the artist's work brought about a complete change of attitude. The enthusiastic response to the shows surpassed all expectations. Great numbers of visitors and many favorable reviews and comments bore witness to the surprise and pleasure the originality of her art had evoked. "Grandma Moses is one of the key symbols of our time. . . . She is clearly an artist, whose paintings reveal a quality identical with genius. . . ." wrote a critic for the noted London magazine *Art News and Review*.

These European exhibitions and some lectures on American folk art I had given met with such interest that in 1954 the Smithsonian Institution organized the show "American Painting: Peintres Naifs from 1700 to the Present." It was circulated in Europe by the United States Information Agency. The collection, which included works by Grandma Moses, presented a cross-section of American folk painting. The confrontation of European art circles with what had been until then a totally unfamiliar form of American painting proved most instructive.

In contrast to Europe, no art schools had existed in America until well into the nineteenth century. People who painted had to find their own technical and artistic means of expression. The importance of this art had not been recognized until fairly recently. Within the framework of the show, Grandma Moses proved to be not so much an isolated figure as a link in a long chain. Each of these untaught artists had found his individual way of expressing ideas of his time and experiences of his daily life. Like all "peintres naifs," they painted for pleasure in their spare time. Edward Hicks (1780–1849), the painter of the *Peaceable Kingdom,* was a Quaker preacher; John Kane (1860–1934), a manual laborer, mainly depicted the industrial landscape of Pittsburgh; Horace Pippin (1888–1946) took his inspiration from a Negro cultural background. Grandma Moses was a farmwife and her work re-creates the American rural scene.

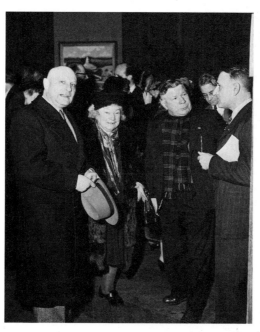

71. Opening, Grandma Moses exhibition, Paris, December 1950: M. Bizardel, Director of Fine Arts, Musées et Bibliothèque de la Ville de Paris, with the French Primitive painter Camille Bombois and Mme Bombois

72. At the opening of the Grandma Moses exhibition in Paris, December 1950: Darthea Speyer, then Assistant Cultural Officer of the U.S. Embassy, Paris, with Jean Cassou, art historian, then chief curator of the Musée National d'Art Moderne, Paris

"My Life's History"

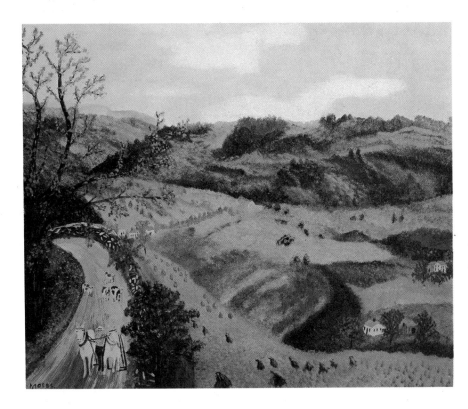

73.
My Homeland.
1945. 16 x 20"

GRANDMA MOSES'S AUTOBIOGRAPHY, *My Life's History,* is the most important source of first-hand information about the artist.

The ability to express herself in a highly personal and original way has already been mentioned. I was convinced that what had appeared in print in 1946–47 was but a small part of what she had to say. Therefore, I urged her to write more about her life. She wrote a short piece titled "I Remember," which was published in the *New York Times Magazine* in 1948. It began:

> What a strange thing is memory, and Hope, one looks backward, the other forward, The one is of to day, the other is the tomorrow, memory is History recorded in our brain, memory is a painter it paints pictures of the past and of the day,

Her autobiography was to open with these words. In the course of the next few years she jotted down little stories and sketches, sending in all 169 handwritten pages; of these only 37 deal with the years in which she had become a world-famous artist, an indication of how

little importance she attached to her success as a painter, as compared to the vivid recollections of the full life she had led before as farmwife and head of a large family.

When Grandma Moses came to New York in 1949 I tried using a tape recorder to spare her the trouble of writing down her memories. But she disliked microphones; she preferred, she said, to write everything herself. After the principal content of the book had been written and its general plan had emerged, she dictated connecting passages at her home in Eagle Bridge. Some corrections in spelling were made at her insistence, although the editor was reluctant to alter what he regarded as part of her characteristic way of expressing herself.

Descriptions of everyday life on the farm alternate with recollections of historical events, such as the death of President Lincoln and the still strained relations between North and South long after the Civil War. Many of these memories form a lively commentary to the paintings that illustrate them.

At the end of the book Grandma Moses summarizes:

> In the foregoing chapters I have tried to tell you many true facts as they were in my days. It is hard in this age for one to realize how we grew up at all. I felt older when I was 16 than I ever did since. . . .
>
> Things have changed greatly and still are changing, can they change much more? . . .
>
> And yet I wonder sometimes whether we are progressing. In my childhood days life was different, in many ways, we were slower, still we had a good and happy life, I think, people enjoyed life more in their way, at least they seemed to be happier, they don't take time to be happy nowadays. . . .
>
> I have written my life in small sketches, a little today, a little yesterday, as I thought of it, as I remembered all the things from childhood on through the years, good ones, and unpleasant ones, that is how they come, and that is how we have to take them. I look back on my life like a good day's work, it was done and I feel satisfied with it. I was happy and contented, I knew nothing better and made the best out of what life offered. And life is what we make it, always has been, always will be.

The book was published in 1952 (Harper); it subsequently appeared in England and, in translation, in Germany and Holland.

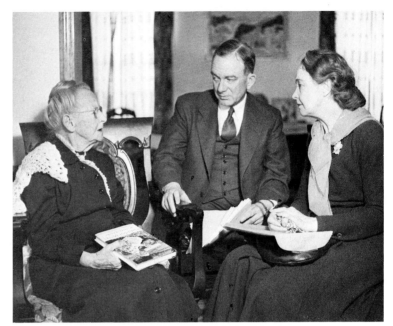

74.
Grandma Moses,
Otto Kallir, and Lillian Gish
in Eagle Bridge, 1952

David Shaw wrote a dramatization which was televised in March 1952, with Lillian Gish playing the role of Grandma Moses.

Several years later, on one of my visits, Grandma Moses gave me a composition written in her own hand in the year 1874. She had later added a penciled line: "This was last day of school." I seem to remember her telling me that she had given this speech in class at the end of her last school year. It is titled "Let Home Be Made Happy." Anna Mary was fourteen at the time, yet her handwriting already resembles that of the mature woman.

Even though the teacher must have helped formulate the text, the ideas it expresses give insight into the young girl's mental capacity. The guidelines for "good and happy living" she set down at that time are no different from those she practiced throughout her life. She must have treasured this paper, for she kept it from youth on into her old age.

The artistic inclination that showed itself so early is revealed by her remarks on the importance of bringing happiness and harmony to a home by decorating it and making it ever more beautiful; ". . , then let man be happy in adorning his home. in making his home the dwelling of happiness and comfort. let him as far as circumstances will permit be industrious in surrounding it with pleasing objects in decorating it within and without with things that tend to make it agreeable and attractive. . . ."

75. ▶
"Let home be made happy,"
written by Anna Mary in 1874

Let home be made happy.

Industry is a homely virtue yet worthy of all praise. even nature herself reads us a lecture upon it. Let us go for a moment from the homes of men to the quiet forest.

here we shall find no discord or tumult of worldly traffic. it is silent. but look around and see what has been done by the busy hand of nature. will you look at nature and see her with industrious fingers weaving flowers and plants and grasses and trees and shrubs to ornament every part of the earth. and will you go home no wiser for this hint? Will you go home to that dear spot upon which the heart should shine as the sun in spring-time shines upon the flowers. and permit it to be the scene of idleness negligence and waste.

Will you permit it to be a naked shelter from the weather. like the den of a wild beast. will not adorn it by your industry as nature adorns the fields and the forest.

if you say that this is somewhat fanciful and should be regarded rather as an illustration then let it be so. still are not the works of nature designed to have an influence of this kind upon us. then let man be happy in adorning his home. in making his home the dwelling of happiness and comfort. let him as far as circumstances will permit be industrious in surrounding it with pleasing objects in decorating it within and without with things that tend to make it agreeable and attractive. let industry and taste make home the abode of neatness and order a place which brings satisfaction to every inmate and which in absence draws back the heart by the fond memories of comfort and content. let this be done and this dear spot will become more surely the home of cheerfulness.

kindness and peace. The parents who would have their children happy must be persevering in bringing them up in the midst of a pleasant. cheerful. a happy home.

there are many happy homes scattered all over our land. some are princely abodes in the city. others beautiful suburban residences. but among them all there are none more homelike and peaceful than those quiet farmhouses we find among the green hills and fields of the country and none seem more deserving to be called dear home. in them we find freedom from the weary rounds of fashion. The wife and mother finds time to devote herself to her children. and her examples and influence impress on their minds those principles which will govern their whole after life.

waste not your time in gathering unnecessary wealth for them but fill their minds and souls with seeds of virtue.

Let children join with their parents in trying to make home a happy place. they can at least practice obedience to parents and kindness to all around. For if you do not when you come to leave it. oh! how much you will think of home. but leave it you must soon the lapse of years will bring around the time when you are to go from home you are to leave that dear old place to go out in the world to meet its temptations and to contend with its storms. The day will come in which you are to leave the fireside of so many endearments. the friends endeared to you by so many acts of kindness. you are to say "Goodbye" to your Mother you are to leave a Fathers protection to go forth and act without an adviser. and rely upon your own unaided judgment you are to bid farewell to Brother and Sister no more to see them but on occasional visits at your home.

Oh! how cold and desolate will the world appear. how your heart will shrink from launching forth to meet its tempest and its storms. Then you will think of your happy home and say.

Mid pleasure and palaces though we may roam
Be it ever so humble there's no place like home.
Farewell peaceful cottage farewell happy home.
Forever I'm doomed a poor exile to roam
This poor aching heart must be laid in the tomb
Ere its cease to regret the endearments of home.

Ceramic Tiles

ANNA MARY'S DESIRE TO MAKE HER SURROUNDINGS PLEASING TO THE eye remained with her throughout her life. There exist a number of objects decorated by her own hand, such as the case of an old clock and those tree mushrooms known popularly as "the Artist's Fungus," which become hard as wood when dried. On these she painted small landscapes. When Mrs. Helen C. Beers, a friend who lived in a neighboring town, suggested in 1951 that she try making sketches on ceramic tiles, she took up the idea with great pleasure. The comparatively easy technique and the playful, noncommital way she could jot down "what the mind may produce," as she once wrote, appealed to her. Mrs. Beers, who worked in ceramics as a hobby, provided six-inch-square tiles and ceramic paints, and instructed the ninety-one-year-old artist in their use.

Over a period of about a year, Mrs. Moses did eighty-five tiles. Some are simple designs, almost drawings, with spare use of color; others are little paintings whose flowing colors make interesting effects on the ceramic background. Mrs. Beers glazed and fired the completed tiles (plates 77–82).

77–82.
Ceramic tiles.
1951–52. Each 6 x 6″.
Numbered and titled
on the reverse by the artist.

No. 2: *A House*

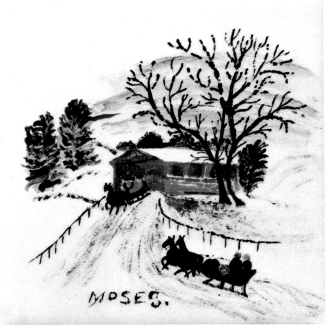

No. 16: *Narrow Road*

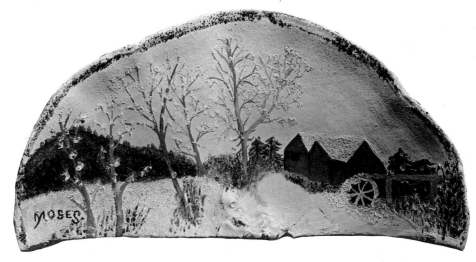

76.
Painting made
on a tree mushroom

No. 35: *Playing*

No. 26: *Church Goers*

No. 42: *Hilltop*

No. 51: *The Marsh*

1946 to 1953

83.
Covered Bridge with Carriage.
1946. 27½ x 21½″.
The Shelburne Museum, Shelburne, Vt.

84.
A Tramp on Christmas Day.
1946. 16 x 19⅞″.
The Shelburne Museum, Shelburne, Vt.

85. *Taking Leg Bale for Security.* 1946. 27 x 20¾″. Collection George M. Newell

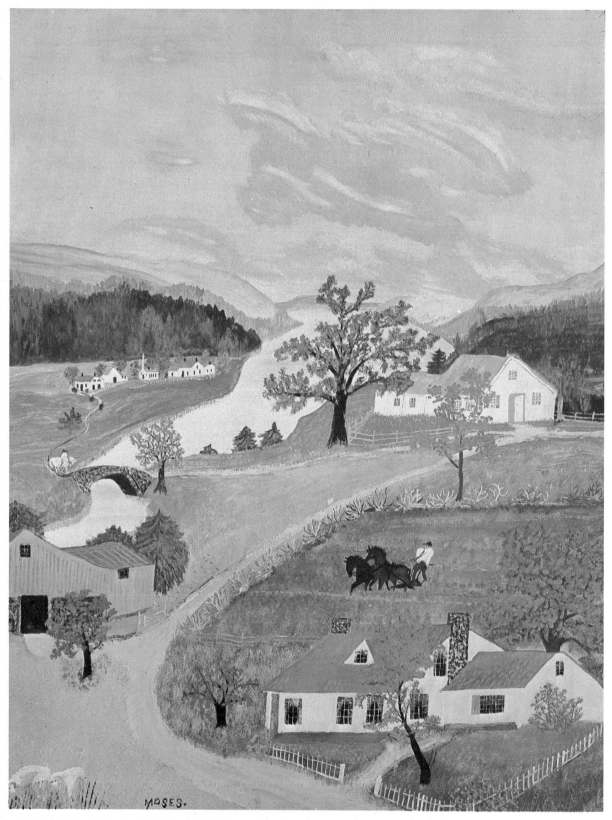

86. *The Spring in Evening.* 1947. 27 x 21″. Private collection

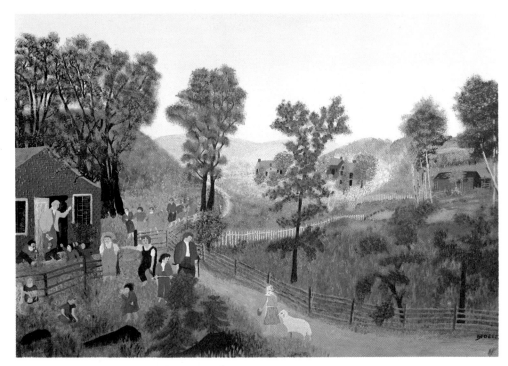

87. *Mary and Little Lamb.* 1947. 24 x 34½″. Collection Mrs. F. Kallir

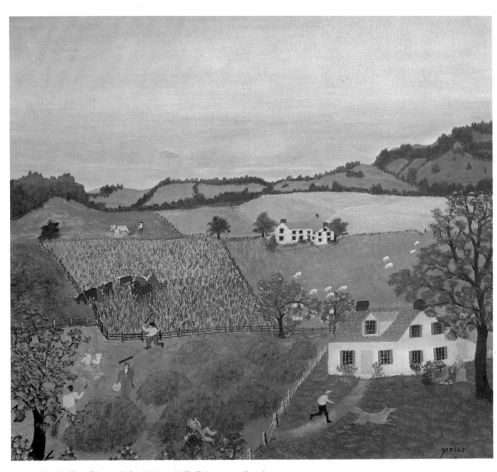

88. *Little Boy Blue.* 1947. 20½ x 23″. Private collection

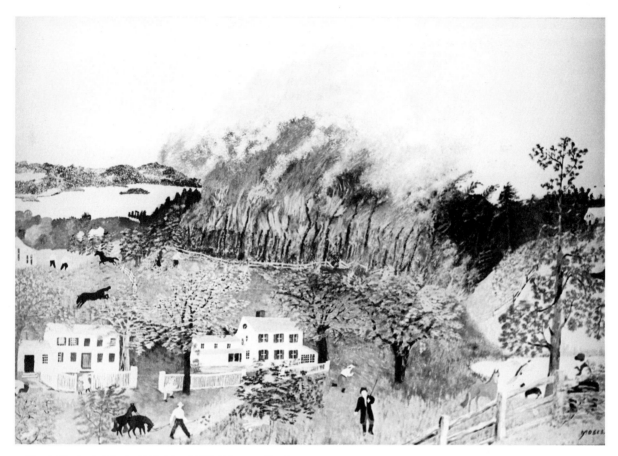

89. *A Fire in the Woods.* 1947. 24 x 36¼″. Private collection

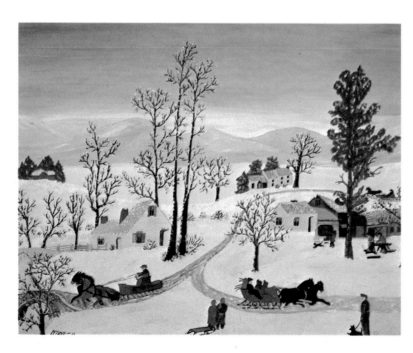

90.
The Dividing of the Ways.
1947. 16 x 20″.
Private collection

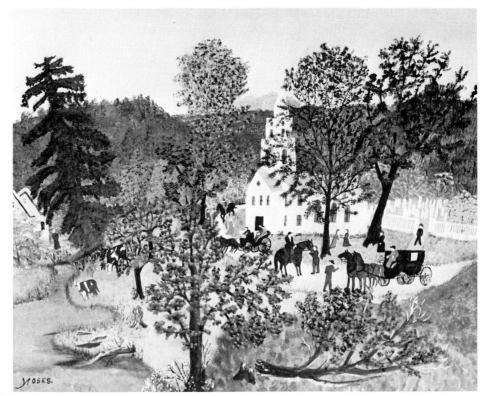

91.
The Church in the Wild Wood.
1948. 16¼ x 20″.
Collection Mrs. William Hayward

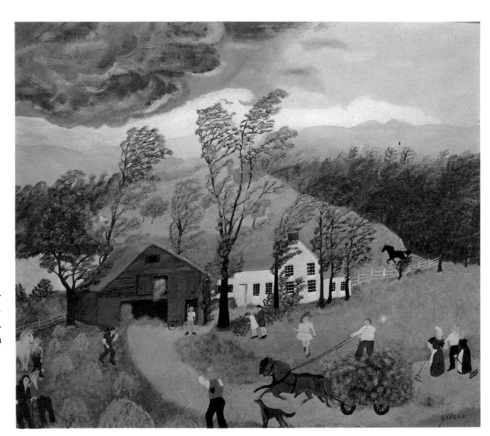

92.
The Thunderstorm.
1948. 20¾ x 24¾″.
Private collection

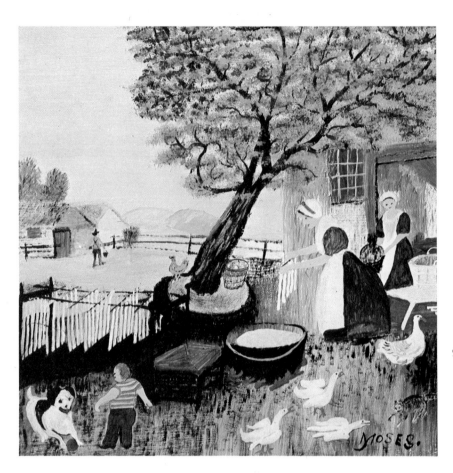

93. *Candle Dip Day in 1800.* 1950. 9 x 9¼″.
Private collection

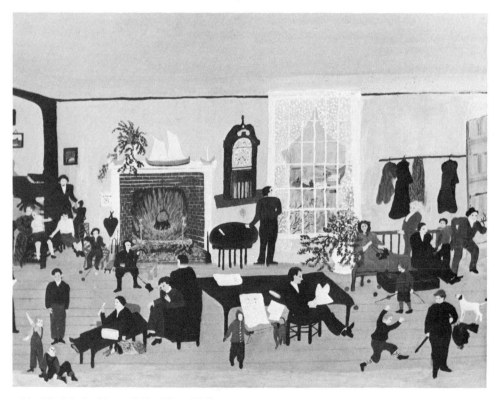

94. *The Meeting House.* 1949. 18¾ x 26¼″

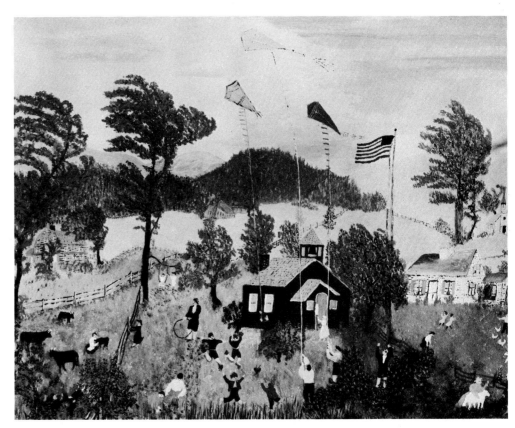

95.
Flying Kites.
1951. 18¼ x 24″.
Collection Mrs. Arthur Choate, Jr.

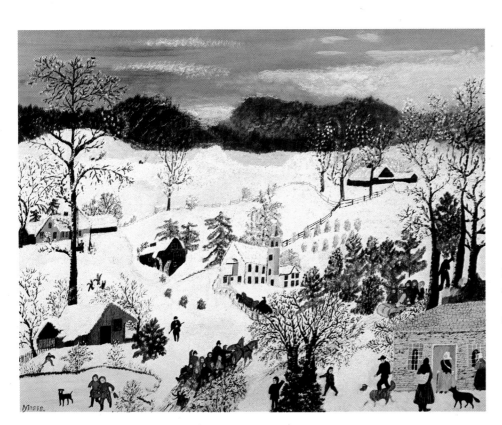

96.
It Snows, Oh It Snows.
1951. 24 x 30″.
Collection Mrs. F. Kallir

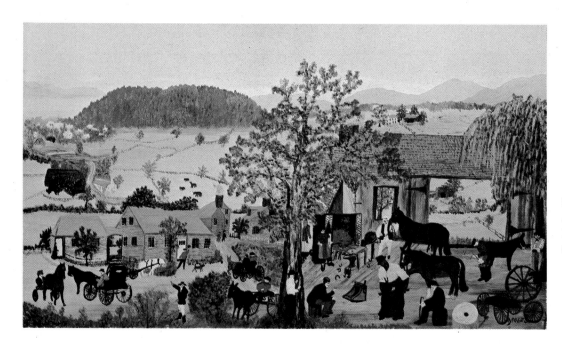

97.
Blacksmith Shop.
1951. 16 x 28″.
Collection Mrs. Forrest K. Moses

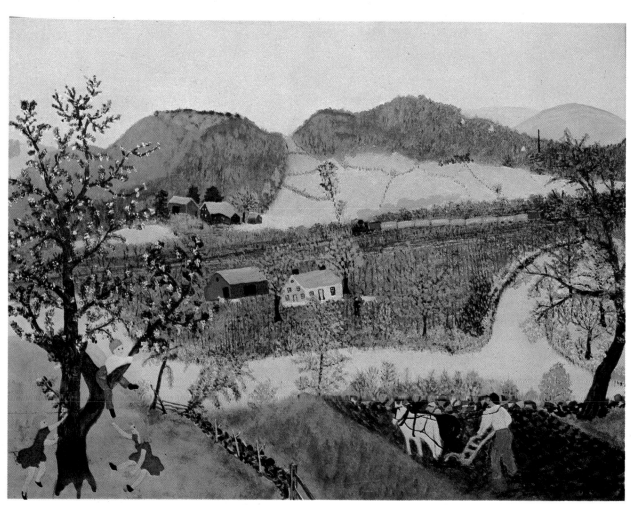

98. *Hoosick River, Summer.* 1952. 18 x 24″. Private collection

3

FAME

New York Herald Tribune Forum, 1953

AMONG THE EVENTS IN WHICH GRANDMA MOSES took part during the last decade of her life was the 22nd Annual Forum arranged by the *New York Herald Tribune* in October 1953. The theme chosen for that year was "New Patterns for Mid-Century Living." The symposium took place in the Grand Ballroom of the Waldorf-Astoria Hotel and was attended by two thousand delegates. The opening address was to have been delivered by Dag Hammarskjold; it was read in his absence by Dr. Ralph Bunche. Among other prominent speakers were John Foster Dulles, Secretary of State, and Francis Henry Taylor, Director of the Metropolitan Museum of Art in New York.

Grandma Moses came to New York with her daughter, Mrs. Fisher. Her appearance was scheduled for the third session, on October 20. The subject for that day was "Time on Our Hands," and the discussion centered on "how the extra hours, the leisure time created by technical advances could best be put to use." After I had given a brief address on "Amateur Painters in America," I introduced the artist and we had an informal conversation—we had discussed it in general terms, but it was not rehearsed.

When she came onto the stage, a little bent but walking with firm steps toward her chair, she was given a standing ovation. Smiling, she faced the crowd, took her seat, and, producing a handkerchief, waved to the audience. This gesture of gracious and spontaneous response brought renewed cheers and applause. It was characteristic of her complete lack of self-consciousness and immediately created an atmosphere of warmth between her and the audience. In the following dialogue she answered all my questions without a moment's hesitation, sometimes interspersing her answers with joking remarks, to the great delight of her listeners. The way in which she spoke about the subject closest to her heart—her painting—and the great modesty with which she regarded her artistic achievement were received by the audience with increasing admiration. The impression Grandma Moses made was expressed by an editorial published in the *New York Herald Tribune* of October 22, 1953:

> For all who suffer from what might be called living strain—and
> many do complain about the malady—a few minutes' exposure to

99. Grandma Moses's ticket

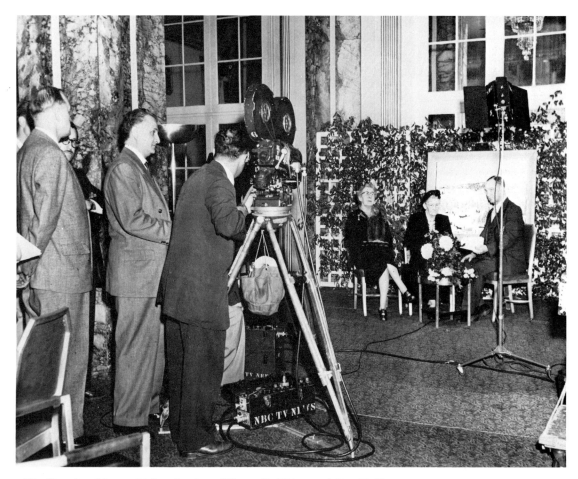

100. Grandma Moses with her daughter, Winona R. Fisher, and Otto Kallir,
filmed for NBC-TV News, after the *Herald Tribune* Forum

the presence of Grandma Moses is powerful therapy. On Tuesday
this ninety-three-year-old lady made one of her rare trips to the
city from her up-state home in Eagle Bridge, N.Y., to appear at the
annual *Herald Tribune* Forum. Some said that she stole the show.
Others were impressed with her astonishing vitality, her mental
alertness, her humor, simplicity, graciousness, enjoyment of the
occasion, and so on. The plain fact is, everybody felt reinvigorated
while in her presence. . . .

She holds within herself, in utter unawareness, the wisest secrets
of life, secrets composed of many elements, yet as natural and
immediate in their expression as a child's smile. While many
distinguished persons were appearing before the Forum, a little
old lady of ninety-three stepped into their midst and endeared
herself to all by her simple aliveness. . . .

Grandma Moses and
Edward R. Murrow, 1955

IT HAD LONG BEEN MY WISH to observe Grandma Moses while painting, but she seemed reluctant to let me watch, so I did not insist. It turned out that she did not consider it proper for a gentleman to enter her bedroom, which she used as a studio. Situated on the second floor of the old house, it was reached by a steep staircase which she climbed countless times a day. After she moved into the new house, she painted in a small room behind the kitchen, and there I could sometimes watch her at work for a few minutes.

Then, in 1953, Edward R. Murrow, the radio and television commentator, wrote to Grandma Moses about interviewing her for television. This seemed to me a good opportunity to film the step-by-step creation of a painting. I knew from experience that she could face any unfamiliar situation or person with complete self-assurance, yet I felt a little uneasy at the thought of a meeting between two such entirely different personalities. However, the importance of the project prompted me to persuade Grandma Moses to go through with this rather strenuous task. Mr. Murrow and his associate, Fred Friendly, agreed to the idea wholeheartedly. The project remained in the planning stage for two years; it was finally realized for Mr. Murrow's television program "See It Now."

The crew of CBS technicians stayed in Eagle Bridge not only for the interview itself, which took place on June 29, 1955, but until the artist had completed an entire painting in front of the cameras. We were in the midst of a heat wave, not exactly the best time to spend many hours under hot floodlights. Everyone was a little tense and uncomfortable, everyone except Grandma Moses, who remained cool and unruffled throughout. The crew had brought along two large movie cameras; one was mounted high above the table on which the artist worked, the other faced her at a distance of about fifteen feet. It was thus possible to take pictures of Grandma Moses as she painted and at the same time to follow the progress of her work in every detail. The artist, who was close to ninety-five, worked for several days under the hot lamps.

101.
Grandma Moses painting in the room
behind the kitchen.
Photo by Ifor Thomas

She had chosen one of her favorite subjects, a sugaring-off scene. After grounding a Masonite board with flat white paint that she applied with a broad housepainter's brush, she took a pencil and drew a fine line across the upper part of the board to mark how far the sky would go. She then took a narrower brush and began to paint the sky, starting at the left. While working, she explained that it was going to be an overcast winter's day; otherwise she would have painted the sky a light blue or a blackish gray, according to whether she wanted to represent a sunny day or perhaps an oncoming snowstorm. After completing the sky, she again took the pencil and indicated with a few delicate lines the contours of mountains and hills. She then proceeded to paint these, either squeezing the various colors directly onto a fine brush or mixing them in small bowls and thinning them with turpentine; for this purpose she often used the lids of preserve jars. She now painted the distant mountains in shades of blue and the closer hills in brown and greenish tones. Without finishing the upper part of her painting, she again took up her pencil and began drawing objects in the foreground, trees and houses, all in scarcely visible outlines, as if only to reserve a certain place for each. After doing

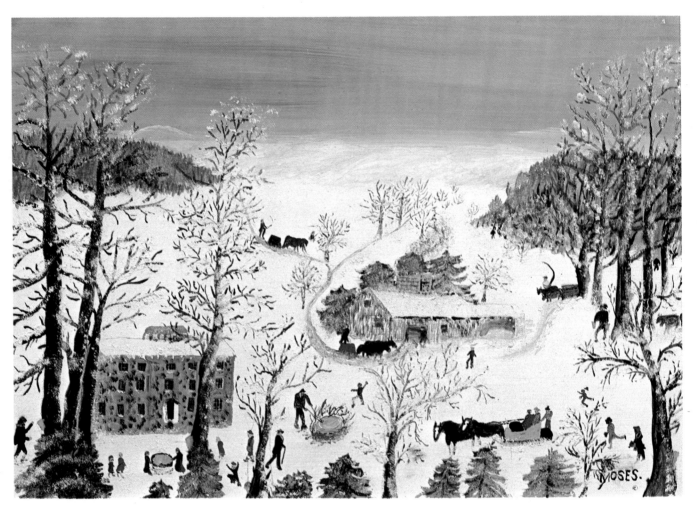

102. *Sugaring.* 1955. 11⅛ x 16″

this, she began to work on the whole picture, now in this, now in another part, here a tree that reached over the entire surface up to the top, there some small shrubs and trees to form a border in the foreground. Once in a while she would interrupt her work for a moment, close her eyes, and then quickly fill in an empty space with the outline of a house, because "something had been missing here." But there was never any prolonged pause that might indicate that the artist was uncertain how to proceed. She always appeared to be following a plan and to know exactly what was to come next and what the final result was to be.

She painted the figures directly into the picture without first sketching them. It was interesting to see how she repeated certain types from previous versions of that specific subject. She seemed to know their exact functions so well that she could easily put them in their proper places. While working on a house or a tree, she sometimes interrupted

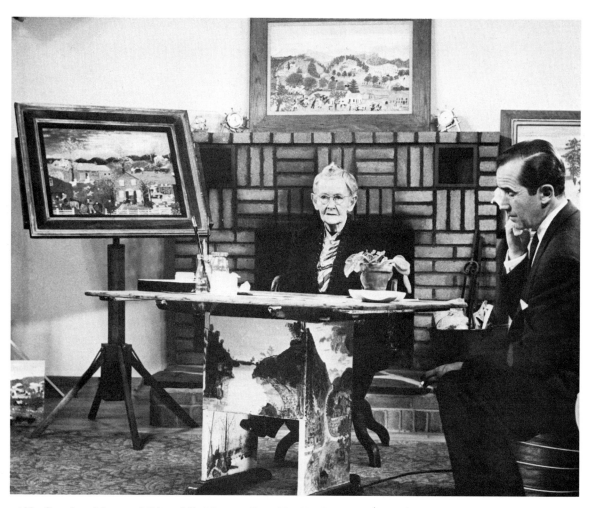

103. Grandma Moses and Edward R. Murrow, June 29, 1955. Interview for "See It Now."
Grandma Moses painted *Sugaring* during and after the interview

herself to dab a few spots of brown, blue, or red here and there; these would become dresses, shoes, or the hat of a man who could soon be recognized. After she had taken up a fine brush and indicated face and hands by little pink spots, she sometimes used a match or even a pin to put in the eyes and the mouth, "because the brushes are not fine enough." One could observe her imagination at work and see how each figure she painted meant something to her. After completing the painting (plate 102), she took "glitter" from a box and sprinkled it on the snow that covered the ground and the branches. A friend had in previous years tried to dissuade her from this "treatment" of her pictures, but she could not understand his objection. She said that if he had ever seen the snow on a sunny day, he would realize that it glitters.

The interview with Edward R. Murrow began after the painting was grounded and sketched. Grandma Moses did not share the general

excitement; she had watched the complicated preparations with amusement and a trace of irony.

The "tip-up" table, which she had decorated with landscapes long before, had been brought into the living room for her to work on. After a few opening questions by Ed Murrow, Grandma pushed aside her painting and began interviewing her interviewer. She put a piece of paper before him and told him to draw something. When he protested, saying he could not draw, she replied with her usual remark that anybody could and that there was nothing to it. After that, the interview developed into a lively conversation touching upon many subjects, no longer a matter of questions and answers but an animated give-and-take that did not lag for a moment. Those present were somewhat taken aback by Murrow's last question: "What are you going to do for the next twenty years, Grandma Moses?" Without faltering for a second, seriously and calmly, she raised her hand and said: "I am going up yonder. Naturally—naturally, I should. After you get to be about so old you can't expect to go on much farther."

> MURROW: But you don't spend much time thinking about it or worrying about it. Do you?
>
> GRANDMA MOSES: Oh, no. No. No. You don't worry because you think, well, what a blessing it will be to be all united again. I'm the last one left of my sisters and brothers. . . .
>
> MURROW: So this is something that in a sense you have no fear about or no apprehension?
>
> GRANDMA: Oh, no. Go to sleep and wake up in the next world. I think that's the way. Did you ever know when you went to sleep?
>
> MURROW: No, I don't think so.
>
> GRANDMA: When the last thought came—you didn't know.
>
> MURROW: No. That's true.
>
> GRANDMA: You might wake up the next morning and think, well, that's what I was thinking about, but you didn't know when that last thought came. Well, that's the way you'll go to sleep.

Murrow, so poised and aloof, was visibly taken off guard by the turn of the conversation and closed the interview with the words: "Well, you will leave more behind you than most of us will, when you go to sleep."

Ed Murrow and all who had witnessed the interview felt that it had been an unforgettable experience. When CBS arranged a program on April 30, 1965, in commemoration of Edward Murrow's death, the last part of his interview with Grandma Moses was included among the most memorable moments of his broadcasting career.

Painting the Eisenhower Farm

For "Grandma" Moses, a real artist —

From a rough amateur —
with best wishes

Dwight D. Eisenhower

France, March 1952.

from the Eisenhowers, Marnes la Coquette

OUR POND AT
VILLA SAINT PIERRE
ORIGINAL BY D.D.E.

104. Card from General Dwight D. Eisenhower

GRANDMA MOSES HAD ALWAYS ADMIRED GENERAL EISENHOWER, and he in turn had long shown interest in her art. Himself an amateur painter, he had devoted much time to this hobby before becoming president.

In 1952, while still in France, he sent Mrs. Moses a reproduction of one of his paintings with a hand-written inscription. She treasured this tribute to her art, and had it framed and hung in her living room.

Toward the end of 1955, President Eisenhower's Cabinet decided to mark the third anniversary of his inauguration by giving him a Grandma Moses painting. It was agreed that she would paint a picture of the Eisenhower Farm at Gettysburg, Pennsylvania.

She had never been there, and was uncertain how to comply with this unusual request, but she felt greatly honored by the "order" and was ready to try her best. She was sent about twenty black-and-white and color photographs showing house and grounds from all sides. Using this material as a guide, she created two paintings each giving a different view of the farm. The more representative one (plate 105) was selected and given to the President in a surprise meeting of the Cabinet on January 18, 1956. Vice President Richard M. Nixon acted as master of ceremonies. The next day's issue of the *New York Times* reported:

> The President obviously was happy both with the painting and
> with the artistic liberties the famous artist had taken with his

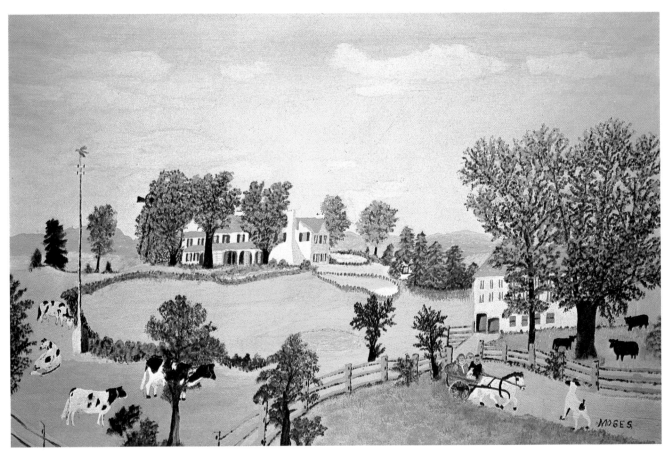

105. *The Eisenhower Farm.* 1956. 16 x 24″. The Dwight D. Eisenhower Library, Abilene, Kan.

Gettysburg property. Farmer Eisenhower is proud of his growing herd of Black Angus cattle. He owns only one Holstein and one Brown Swiss. But Grandma Moses painted four Holsteins to three Angus cattle grazing in the pastures. General Eisenhower was delighted to see the recently built golf green, which had grown in size in the transfer from a photograph to an oil canvas. "I wish it was that big," said the President to Mrs. Eisenhower. He spotted his three grandchildren—David, Susan, and Barbara Eisenhower—riding in the pony cart. The Great Dane that usually precedes them looked more like a wire fox-terrier.

106. A letter to President Eisenhower

Grandma Moses
Eagle Bridge
New York

Jan. 12 1956.

Mr. President,
I was very honored to be asked to paint a picture of your home in Gettysburg.
although most of my paintings are memories and imagination, I tried to do this for you and hope it will please you.
my very best wishes for your continued good health on your third anniversary, as our President,

very sincerely.
Grandma moses,

Historical Themes

GRANDMA MOSES REPEATEDLY USED HISTORICAL EVENTS she had been told about or which occurred in her lifetime as subjects for her paintings.

When President Lincoln was assassinated in 1865, Anna Mary was not quite five years old, but the event remained vivid in her mind throughout her life. In 1957 she painted a small picture (plate 108) showing a village street, with the doors of the church and the houses draped in black bunting. In recollecting this very early experience, she wrote:

> One day, mother, aunt Lib and I, we left Greenwich to come down to grandma's, just above Eagle Bridge where she lived. Mother was driving the buggy, an old fan horse, a gentle horse. . . . I don't remember the trip so much until we got down into Coila. . . .
>
> Mother noticed that everything was trimmed in black. I remember her saying, "Oh, what has happened?" It was war times. . . . She went into the store and asked what had happened. The pillars on the store were all wrapped in black bunting. And this man told her that President Lincoln was shot the night before. And I remember her coming back to the buggy and she said to aunt Lib, "Oh, what will become of us now?" And if she hadn't used those words, I don't suppose I would have ever remembered it.

Grandma Moses was especially interested in the history of her neighborhood and knew a great deal about it. The Revolutionary War, in which some of her ancestors had taken part, particularly fascinated her. In 1953 she painted three pictures of the Battle of Bennington (plate 107), which had taken place close by—the site is marked by a monument. In preparation for her work she looked up many historical details in reference books. In the first two versions she painted the monument in the background; when it was pointed out to her that this was an amusing error, since naturally no monument existed at that time, she made a third painting without it.

Grandma Moses never ceased to follow current events with lively interest and understanding. In 1959 Alaska became the forty-ninth state of the Union. During the preceding year there had been much discussion about how the new flag should look with one star added to forty-eight. The idea stimulated Grandma's recollections, for she had many times witnessed the growth of the United States and the changing of the flag.

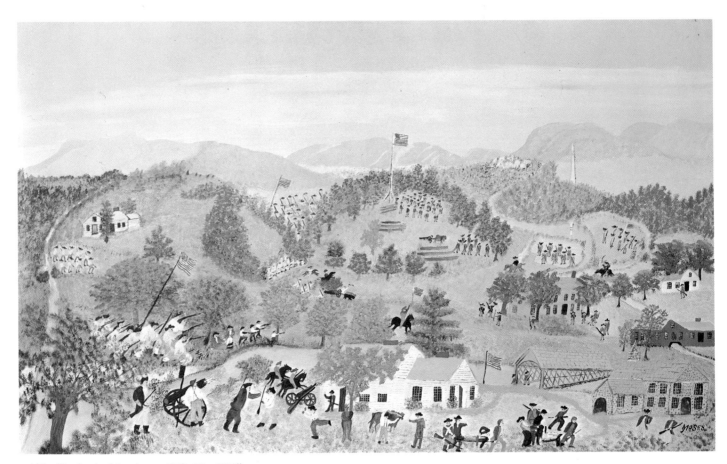

107. *The Battle of Bennington.* 1953. 18 x 30½"

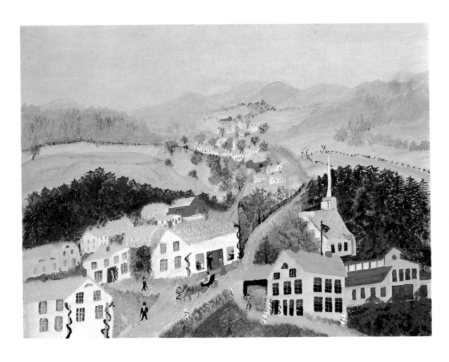

108.
Lincoln.
1957. 12 x 16⅛".
Collection Shirley Futterman

109.
Old Glory.
1958. 12 x 16″

MOSES.

She made a design for the new American flag, basing it on "the first flag with stars and stripes [which] was that of Ticonderoga. It had a circle of thirteen. Why not fill the others in?" she wrote. It was a sketch of just the flag without background, on a 12-by-16-inch board. She called it *Old Glory* (plate 109). On a second small oil painting dated the same day, December 6, 1958, Grandma Moses showed this new flag being hoisted to the accompaniment of salvos from two cannons at the foot of the flagpole.

Hundredth Birthday, September 7, 1960

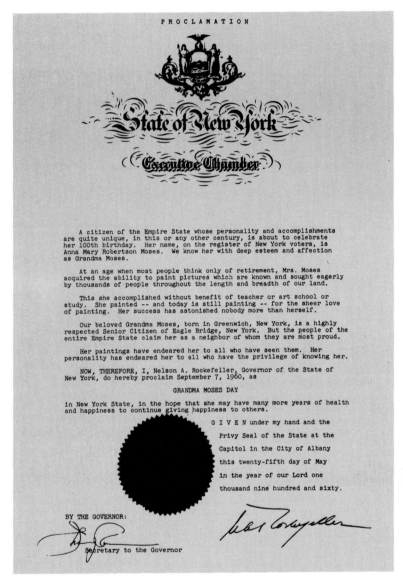

PROCLAMATION

State of New York

Executive Chamber

A citizen of the Empire State whose personality and accomplishments are quite unique, in this or any other century, is about to celebrate her 100th birthday. Her name, on the register of New York voters, is Anna Mary Robertson Moses. We know her with deep esteem and affection as Grandma Moses.

At an age when most people think only of retirement, Mrs. Moses acquired the ability to paint pictures which are known and sought eagerly by thousands of people throughout the length and breadth of our land.

This she accomplished without benefit of teacher or art school or study. She painted -- and today is still painting -- for the sheer love of painting. Her success has astonished nobody more than herself.

Our beloved Grandma Moses, born in Greenwich, New York, is a highly respected Senior Citizen of Eagle Bridge, New York. But the people of the entire Empire State claim her as a neighbor of whom they are most proud.

Her paintings have endeared her to all who have seen them. Her personality has endeared her to all who have the privilege of knowing her.

NOW, THEREFORE, I, Nelson A. Rockefeller, Governor of the State of New York, do hereby proclaim September 7, 1960, as

GRANDMA MOSES DAY

in New York State, in the hope that she may have many more years of health and happiness to continue giving happiness to others.

G I V E N under my hand and the Privy Seal of the State at the Capitol in the City of Albany this twenty-fifth day of May in the year of our Lord one thousand nine hundred and sixty.

BY THE GOVERNOR:

Secretary to the Governor

110.
Proclamation by Governor
Nelson A. Rockefeller, 1960

PREPARATIONS FOR THE HUNDREDTH BIRTHDAY of Grandma Moses began early. In May 1960, Governor Nelson A. Rockefeller issued a proclamation declaring September 7 "Grandma Moses Day" in New York State.

As the day approached, many newspapers requested personal interviews. Fearing that it would be too strenuous for the centenarian to have dozens of reporters descend on her home in Eagle Bridge, her family allowed only a very few to see her. One of the most sensitive reports was written by Joy Miller of the Associated Press, whose article was published nationwide on September 4:

Your impression of Grandma Moses is that she is very fragile and very old. She's sitting in the living room, looking small at one end of a big sofa, wearing a blue print dress and pink sweater, with a black ribbon around her throat. Her arthritic fingers are curled together in her lap. You advance hesitantly. How do you address America's best known primitive painter? . . . Is it too forward to call her "Grandma"? . . . Do you have to shout?

But she has sighted company. Her face lights up in a gamin grin, her hazel eyes sparkle behind their spectacles. Her welcoming hand grasps yours with startling vigor.

As she chats about this and that, the character of a remarkable woman emerges: kindly, humorous, unaffected, indomitable, with sight and hearing in admirable repair. You become aware that her seemingly frail 100-pound frame supports a spirit that's at once robust and ageless.

From the beginning of September, mailbags full of cards and letters swamped the Eagle Bridge Post Office. Hundreds of telegrams arrived, piles of gifts were stowed away in the sunporch of the farmhouse, where Grandma Moses took loving care of her geraniums, African violets, and coleus. President and Mrs. Eisenhower, Vice President and Mrs. Nixon, and former President and Mrs. Truman sent birthday tributes. President Truman had never failed to remember Grandma's birthday since their meeting in 1949.

For the benefit of friends and neighbors who could not come on the 7th, which was a working day, Grandma Moses's family gave a birthday party at her home on Sunday the 4th. After this, Forrest and Mary Moses had to hold open house for more than a week to accommodate the steady stream of visitors. In the midst of all this excitement Grandma Moses was cheerful and serene and seemed to enjoy everything. When she had realized that her efforts to discourage an elaborate celebration would fail, she said: "I'm going to sit right here, just so, and the others can do the work. I wish they wouldn't fuss, but it's a nice excuse for the young people to get together."

Several weeks went by before the excitement subsided and she could go back to the quiet life she had been leading of late.

In honor of Grandma Moses's hundredth birthday, the IBM Gallery of Arts and Sciences arranged a loan exhibition, "My Life's History," which ran from September 12 to October 6, 1960. The gallery had been inaugurated five years earlier with a comprehensive Moses show.

111. Grandma Moses and Thomas J. Watson, 1955

Although Thomas J. Watson, the artist's longtime friend and active supporter, had died in 1956, his family remained interested in her work, as did the art department of IBM.

The pictures for the birthday exhibition were selected to depict events from the life of the artist as she remembered them. Most of the captions that accompanied the paintings were taken from her autobiography, but a few quotations from the previous book, *Grandma Moses: American Primitive*, were also included.

Prominent personalities who had taken a personal interest in the artist and in her work formed the honorary committee. Among them were former President and Mrs. Truman, Eleanor Roosevelt, Irving Berlin, Jean Cassou, Walt Disney, Lillian Gish, and Thornton Wilder.

"The Night Before Christmas"

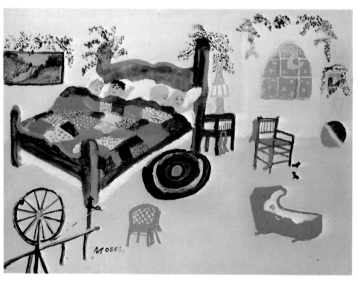

112. *Waiting for Santa Claus.* 1960. 12 x 16″.
Grandma Moses Properties, Inc., New York

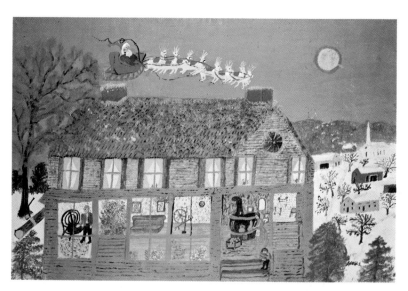

113. *Santa Claus II.* 1960. 16 x 24″.
Grandma Moses Properties, Inc., New York

EARLY IN 1960 GRANDMA MOSES'S STRENGTH HAD BEGUN TO FAIL. She could no longer walk around very much and was more and more confined to the house; painting lifted her spirits and gave her a fresh incentive every day. At that time a proposal was made by Bennett Cerf and Robert Bernstein of Random House that she illustrate Clement C. Moore's famous poem, *The Night Before Christmas*. The idea of creating pictures for a Christmas story did not appeal to her. She had declared time and again that she only wanted to paint scenes and situations she knew from her own experience. She once wrote to me (March 4, 1944): "Some one has asked me to paint Biblical pictures, and I say *no* I'll not paint something that we know nothing about, might just as well paint something that will happen 2 thousand years hence."

Still, she took up the project, for she liked the poem and knew it by heart. At first she dutifully tried to follow the text and painted scenes and objects familiar to a child's conception of Christmas—stockings hanging by the fireplace, candy canes, and toys (plates 112, 113). As her work progressed, her imagination unfolded. *So Long till Next Year* (plate 114), one of the many paintings done for the book (though finally not

published in it), was obviously meant to conclude the series. This work far transcends any factual illustration.

It is a pure artistic expression of almost dreamlike quality and is also remarkable in that this effect is achieved entirely by means of color. The intense blue of a deep, clear winter night is illumined by an almost white moon that bathes the unrealistic feathery branches of the trees in a silvery light; stars are scattered across the dark sky. There are only these two colors, blue and white, except for a few beautifully distributed patches of red—Santa's coat and the red chimneys. The reindeer, quite substantial and lifelike in the other illustrations, are, as they should be, otherworldly apparitions receding into the beyond. One can imagine a child, still half asleep yet expecting the miraculous, stepping to the window in the middle of the night and experiencing this vision of a transformed world.

Grandma Moses's work on the book, begun in March 1960, was interrupted by the commotion caused by her hundredth birthday. She completed the pictures in November of 1960, but did not live to see the book's publication in 1962. It has since become very popular and is read and shown every year on the December 24th telecast of the CBS-TV children's program "Captain Kangaroo."

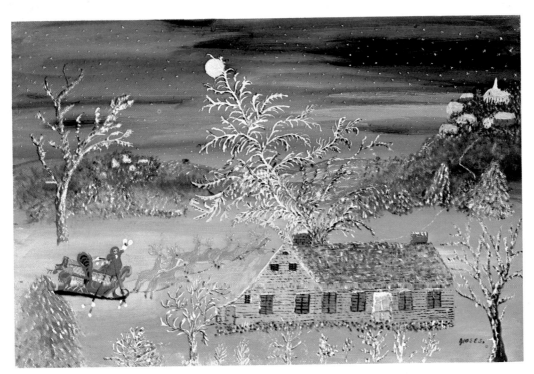

114. *So Long till Next Year.* 1960. 16 x 24″. Grandma Moses Properties, Inc., New York

The Last Months

115. Grandma Moses on her 101st birthday, September 7, 1961

ON JULY 18, 1961, FORREST AND MARY MOSES took Grandma to the Health Center at Hoosick Falls. Forrest wrote me: "Grandma feels good, only for her legs, they are so weak; her hearing is good again and her voice is strong." She had fallen several times, and it was decided that she would be better off under professional care. Grandma Moses was quite unhappy at the nursing home, and hoped her stay there would be only temporary.

As long as she had been at home she had continued to paint, completing more than twenty-five pictures after her hundredth birthday. At the nursing home, however, she was not allowed to do what had become her most important activity. Her physician, Dr. Clayton Shaw, who had been the family's doctor for fifty years, felt that she "would not rest if she had her paints."

THE WHITE HOUSE
WASHINGTON

September 5, 1961

Dear Grandma Moses:

I want again to send you my warmest best wishes
as you reach another milestone in your long and
celebrated career.

Your painting and your personal influence continue
to play a large and valuable role in our national
life.

Both Mrs. Kennedy and I want to wish you best
health and happiness in the years ahead.

Sincerely,

Grandma Moses
Eagle Bridge, New York

116. Letter from President John F. Kennedy

During one of his visits she hid the doctor's stethoscope. When he asked, "Where's my stethoscope?" Grandma Moses replied: "That's what I won't tell you. I hid it. It's a forfeit. You take me back to Eagle Bridge and you'll get back your stethoscope."

Just before her 101st birthday I visited her and found her in good spirits. She was mentally alert and full of plans. "As soon as I get back home, I will start painting again," she said. Asked how she would celebrate her birthday this year, she said: "Much as I enjoy visiting with my friends and neighbors, I have come to see that *one* hundred-year celebration is enough for anybody, and I would like to spend my 101st birthday the same as my first day, very quiet."

Again Governor Rockefeller proclaimed September 7 as Grandma Moses Day in New York State. On that day the Health Center at Hoosick Falls was described as resembling "one huge bowl of flowers," for at Grandma's request the bouquets were shared by the other patients at the home. Among the tributes she received was a letter from President John F. Kennedy.

In October 1961, Random House published *The Grandma Moses Story Book*, a collection of stories for children by various authors, illustrated with her paintings. This was the last of her books the artist saw published.

The Death of Grandma Moses

EARLY IN THE AFTERNOON OF DECEMBER 13, 1961, Dr. Shaw called from Hoosick Falls to tell me that Grandma Moses had passed away a short while before. "She just wore out," he said. Her death had been expected for some weeks; she had grown steadily weaker, her mind had begun to wander, and she slept for long hours. Her daughter-in-law Dorothy had been at Grandma Moses's bedside every day during these last weeks and months.

News of the artist's death was broadcast over all radio networks and published nationwide on the front pages of newspapers. Her passing brought words of sympathy from all over the country.

President Kennedy issued the following statement:

> The death of Grandma Moses removes a beloved figure from American life. The directness and vividness of her paintings restored a primitive freshness to our perception of the American scene. All Americans mourn her loss. Both her work and her life helped our nation renew its pioneer heritage and recalled its roots in the countryside and on the frontier.

Governor Nelson A. Rockefeller said the death of Grandma Moses "is a loss to all of us in New York State and to those everywhere who loved simplicity and beauty. She painted for the sheer love of painting, and throughout her 101 years, she was endeared to all who had the privilege of knowing her."

Of the numerous editorials on her life, her artistic achievement and its meaning for our time, one tribute is reprinted here from *The New Yorker* of December 23, 1961:

> The death of a very old person seems no more natural, no less an untoward incursion, than the death of a young one. Perhaps death seems natural only to Nature herself—and even she may have some doubts. Yet we cannot think of the life, now concluded, of Anna Mary Robertson Moses without cheerfulness. To live one allotted span as a farm wife and the mother of ten children, and then, at the age of seventy-six, to begin another, as an artist, as Grandma Moses, and to extend this second life into twenty-five years of unembarrassed productiveness—such a triumph over the normal course of things offers small cause for mourning. If we do mourn, it

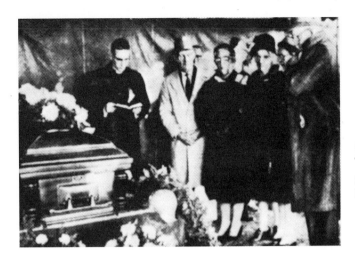

117.
The Reverend Joel B. Miller conducting graveside rites for Grandma Moses, December 16, 1961. UPI Photo

is for ourselves; she had become by her hundredth year one of those old people who, as old buildings civilize a city or spindly church spires bind up a landscape, make the world seem safer. Shaw and Brancusi were examples; Churchill and Schweitzer still are. They pay the world the great compliment of being reluctant to leave it, and their reluctance becomes a benediction.

Grandma Moses was buried on December 16 in a hilltop grave in Maple Grove Cemetery, Hoosick Falls, overlooking the Hoosick Valley. About a hundred friends and neighbors joined with the family in a fifteen-minute Episcopal service conducted at her Eagle Bridge house by the Reverend Joel B. Miller, Rector of St. Mark's Episcopal Church in Hoosick Falls, of which she had been a member. The house was so crowded that mourners stood in the hall and in the kitchen. The priest interpolated into the service phrases of his own which had reference to Grandma's special gifts as an artist, but there were no eulogies.

A thirty-five-car cortege proceeded from the house to the cemetery some five miles distant, with Washington County sheriff's deputies as escort to the county line and Rensselaer County deputies taking over at that point. The day was clear and bright and bitter cold, with temperatures in the low teens, but almost all those at the house continued to the cemetery. Along the route, groups of people waited in front of their homes to pay their last respects.

At the graveside, Father Miller read briefly from the burial service of the Book of Common Prayer. Anna Mary Robertson Moses was buried next to her husband, Thomas Salmon Moses, her son Hugh, and her daughter Winona. The services were marked by the simplicity that was the keynote of Grandma Moses's life. Father Miller said: "It was exactly what she would have wanted—a simple, farmhouse, family funeral."

118.
The grave: Thomas S. Moses/his wife/ Anna Mary Robertson/Winona R. Fisher. At left, grave of Hugh W. Moses. Maple Grove Cemetery, Hoosick Falls, N.Y. Photo by John Woodruff

1953 to 1961

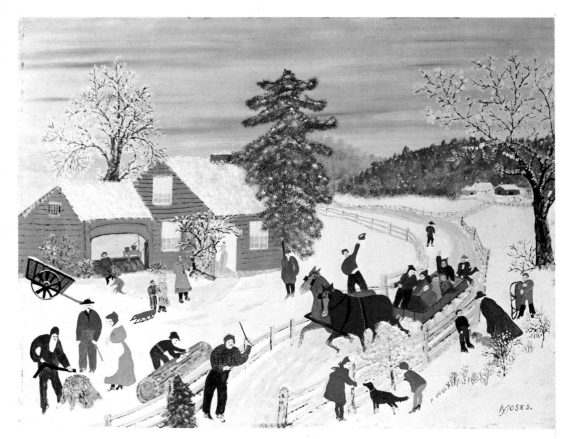

119. *Joy Ride.* 1953. 18 x 24″

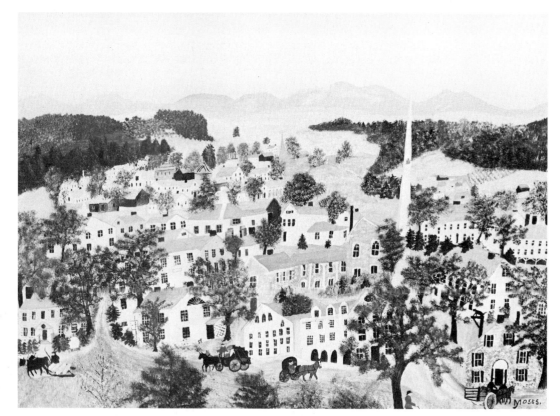

120.
Bennington
1953. 18 x 24″.
Collection George Eisenpresser

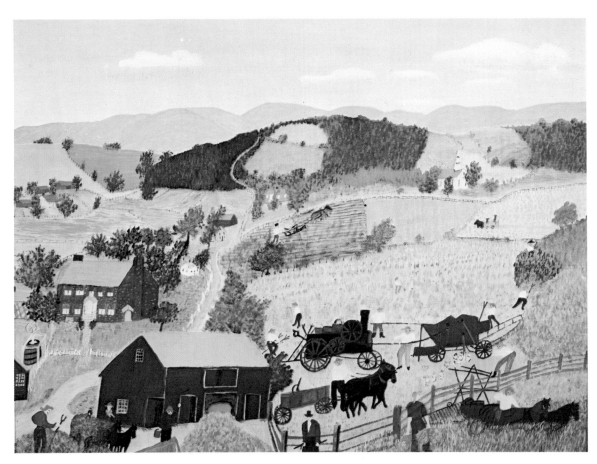

121. *The Thrashers.* 1954. 18 x 24½″

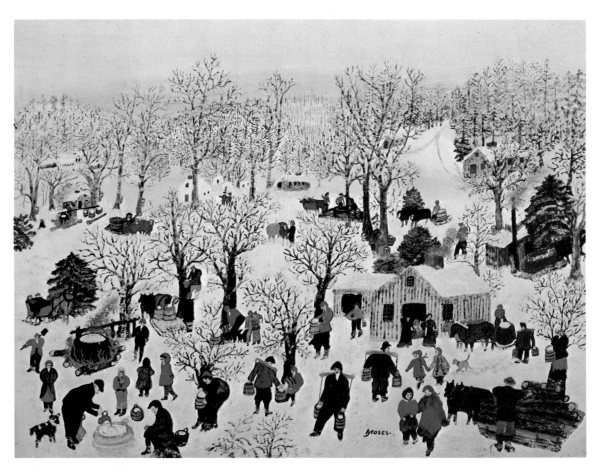

122. *Sugaring Off.* 1955. 18 x 24″

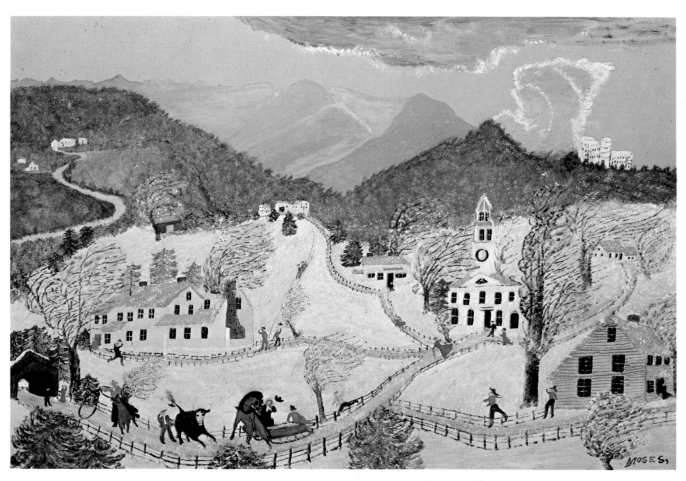

123. *A Blizzard.* 1956. 15⅞ x 24″. Private collection

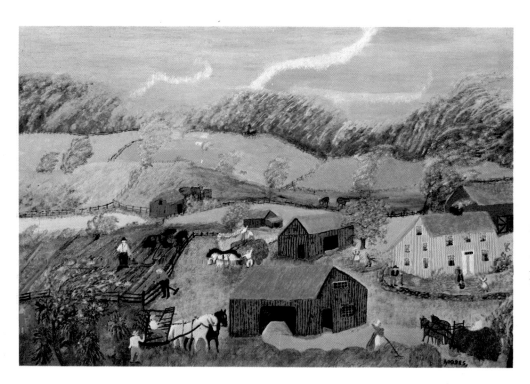

124.
Wind Storm.
1956. 16 x 24″
Private collection

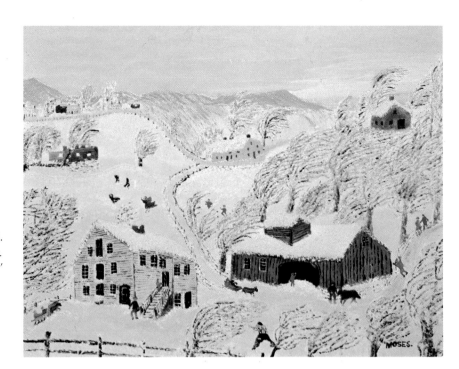

125.
Snowed In.
1957. 12 x 16″

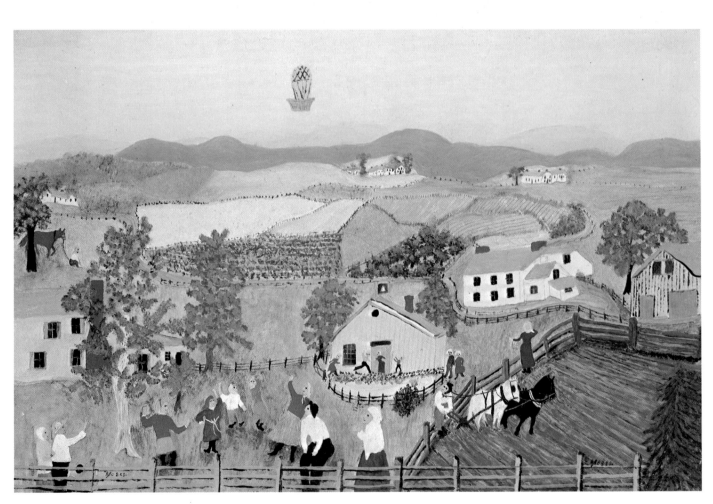

126. *Balloon.* 1957. 15⅞ x 24″. Collection Otto Kallir

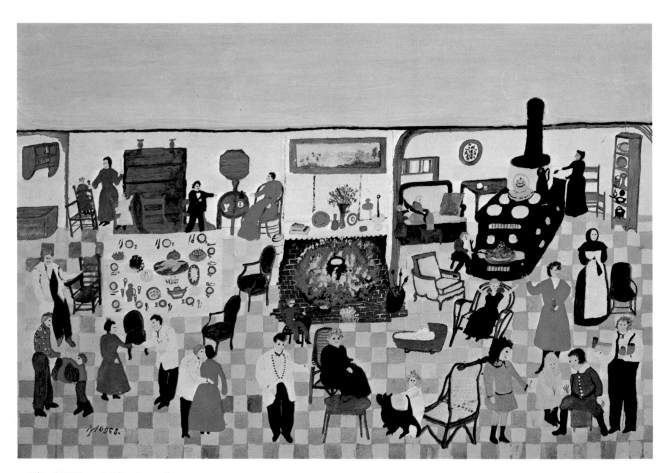

127. *Old Times.* 1957. 16 x 24″

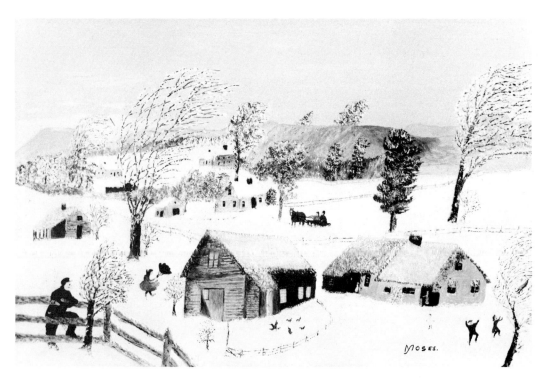

128.
A Blizzard.
1958. 16 x 24⅛″

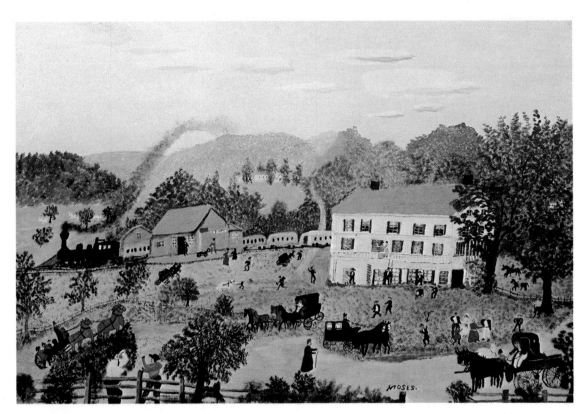

129. *Eagle Bridge Hotel.* 1959. 16 x 24"

130. *Sugar Time.* 1960. 16 x 24"

131. *Get Out the Sleigh.* 1960. 16 x 24"

132. *White Birches.* 1961. 16 x 24"

Exhibitions, 1962–1972

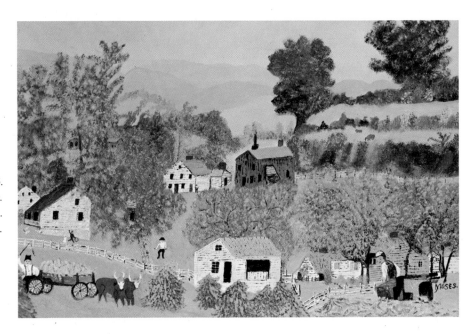

133.
Corn.
1958. 16 x 23⅞".
Pushkin Museum, Moscow, U.S.S.R.

A PHENOMENON OFTEN OBSERVED is that the public's interest slackens after an artist's death; his fame becomes dimmed, his name no longer appears in the news. Then, sometimes, he is rediscovered. Finally the pendulum that has swung far out in both directions levels off to an objective and lasting evaluation.

Such a development seemed very likely in the case of Grandma Moses. So much had been written about her exceptional rise to fame in old age, and now the appealing aura surrounding her person faded with her passing. But the public's interest, far from diminishing, has steadily grown as her art, stripped of anecdotal embellishments, emerges and speaks for itself.

One-man shows and museum exhibitions that took place in the decade following the artist's death were received with great interest. In November 1962, a memorial show was held at the Galerie St. Etienne, New York. The catalogue reproduced details of pictures to draw attention to various characteristics of the artist's painting technique.

A traveling show, sponsored and circulated by the Smithsonian Institution (1962–64) found the greatest response. The collection was presented at museums in nine American cities and thereafter in eight European countries, finally going to Russia at the invitation of the

Soviet Ministry for Culture. It was exhibited at the Pushkin Museum in Moscow in December of 1964. "The show was very well received by the public, once they had overcome their initial surprise," wrote the Counselor for Cultural Affairs of the United States Embassy in Moscow. "Judging by the comments we heard . . . the evident delight that Grandma Moses took in the execution of all her work was the most impressive aspect for the Soviets. They were surprised, and quite pleased, to find a total absence of 'social message'. . . . I would judge that 100,000 viewers would not be too generous an estimate. . . . There were lines of people waiting to see the show. . . . The Embassy regards the Moses exhibit as a successful and very valid effort . . . to increase Soviet understanding of the United States and its people."

From 1964 on, the Hammer Galleries, New York, in cooperation with the Galerie St. Etienne, has been presenting Moses exhibitions at Christmas time.

In 1963, 1965, and 1967 the Bennington Museum in Vermont arranged Grandma Moses shows that met with such lively response that the idea of establishing a more permanent exhibition arose. The Grandma Moses Gallery was opened in a wing of the museum on May 10, 1968. Beginning with her first known picture, the *Fireboard*, "worsted" pictures, and small early paintings, the collection contained prominent works from the artist's two productive decades. In addition, photographs, exhibition posters, and documents conveyed a vivid impression of her life and the development of her fame as an artist. The Grandma Moses Gallery was closed after the 1972 season.

The most comprehensive Moses exhibition ever assembled, titled "Art and Life of Grandma Moses," was presented at the Gallery of Modern Art in New York in 1969. A total of 141 paintings lent by museums and collectors all over the country showed a cross-section of the artist's entire oeuvre.

Shortly after Grandma Moses's death the little one-room schoolhouse in Eagle Bridge, where Anna Mary had gone to school, was up for sale. Her son Forrest and daughter-in-law Mary acquired it and had it moved to a site next to the old Moses farm. Leaving the original structure untouched, they filled it with countless memorabilia, including the old shop sign of Thomas's Drugstore in Hoosick Falls, where Louis Caldor had first seen her pictures, as well as objects and souvenirs she had assembled from childhood on. The schoolhouse was opened to the public in 1966. It has recently been acquired with its entire contents by the Bennington Museum and set up adjacent to it.

134. The Grandma Moses Gallery, 1968–72, at the Bennington Museum, Bennington, Vt.

The Grandma Moses Stamp

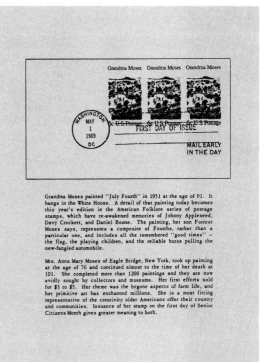

On the First Day of Senior Citizens Month
Honoring All Older Americans
GRANDMA MOSES
Commemorative Stamp Ceremony May 1, 1969

AUDITORIUM
U.S. Department of Health, Education, and Welfare

Washington, D.C.

135. Folder distributed to the guests attending the Grandma Moses Commemorative Stamp Ceremony, May 1, 1969

IN 1969, THE UNITED STATES GOVERNMENT paid tribute to the memory of Grandma Moses by issuing a six-cent stamp, an honor accorded to but a few American artists.

Senator Kenneth B. Keating first brought up the idea on the Senate floor in 1960, on the occasion of the artist's forthcoming hundredth birthday. The *Congressional Record* of June 20, 1960 (vol. 106, no. 113), includes the following statement:

> Mr. President, one of the leading citizens of my State is, in the fullest sense of the word, a citizen who belongs to all the world. She is Anna Mary Robertson Moses of Eagle Bridge, N.Y., better known everywhere as Grandma Moses.
>
> This great lady and artist has brought an inspiring message to people all over the world. Not only has Grandma Moses become a legend in her time; she has also demonstrated to elderly people

everywhere that the opportunity for achievement and satisfaction really knows no age. By her example and through her paintings she has projected a wonderful and indelible image of America to the four corners of the globe.

In my view, the message of Grandma Moses and all she stands for could be communicated ideally through the issuance of a commemorative stamp bearing one of her paintings. It would be a fitting tribute on the occasion of her 100th birthday on September 7 of this year. I have made this suggestion to the Postmaster General and I am hopeful an affirmative response will be forthcoming.

It took nine years for Senator Keating's idea to be realized. When the decision to issue the stamp was finally reached, J. Carter Brown, Director of the National Gallery of Art in Washington, D.C., was asked to suggest a painting. He recommended *July Fourth* (see plate 63), owned by the White House, as a suitable subject. The design for the stamp is a detail from that painting. Printed on a two-plate Giori press in six colors, in an edition of 166,630,400, the stamp was released in a ceremony in Washington on May 1, 1969, marking the beginning of Senior Citizens' Month.

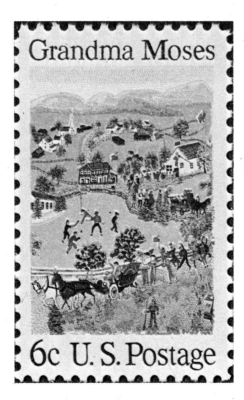

136. The Grandma Moses stamp

4

THE RANGE OF
GRANDMA
MOSES'S ART

From Amateur to Professional
Evolving Her Own Style
Landscapes
Interiors
Last Paintings
Epilogue
"How Do I Paint?"

From Amateur to Professional

In the beginning Grandma Moses worked more or less casually, taking pleasure in painting as she had in doing needlework of different kinds throughout her life. A study of her paintings shows that she made repeated use of motifs borrowed from various sources, combining and recombining them in much the way an experienced housewife uses elements of different patterns in making clothing for her family and decorative objects for her home. At times she also copied from reproductions.

It is not possible to trace all the pictures, mostly of small size, which Grandma Moses made in the period before her true development as a painter. Their style is very inconsistent, and their artistic quality depends more on her feeling for the subject and, perhaps, for the intended recipient of the picture than on her concern with the painting as such.

Then there are the pictures which Louis J. Caldor assembled between 1938 and 1941. The first Moses works to appear at an exhibition were three paintings displayed at the Museum of Modern Art in 1939 and those in her one-man show at the Galerie St. Etienne in 1940. Some of Caldor's purchases may have been painted years earlier, and we know about the exhibited pictures only that they were done previous to the shows.

It is a remarkable phenomenon that Grandma Moses's mind always remained alert, open, and eager to take up new suggestions if they appealed to her. Thus, within the period of a very few years, what had at first been a hobby and pleasant pastime became a full-time professional activity. She even learned to manage some sort of "bookkeeping" with regard to her work, conscientiously filling orders and requests, noting data and prices, and personally supervising the shipping of her paintings.

In November 1941, when people had begun to be interested in Grandma Moses, her youngest brother, Fred E. Robertson, a talented self-taught artist in his own right, gave her a book in which to record her paintings. The book is bound in black boards; it measures 7¾ by 10 inches and bears the word "Record" in gold lettering on the cover. The pages are numbered from 1 to 152, and the first one is inscribed in Fred Robertson's hand (plate 137). To make it easier for his sister to keep

137–39.
Pages from the artist's Record Book

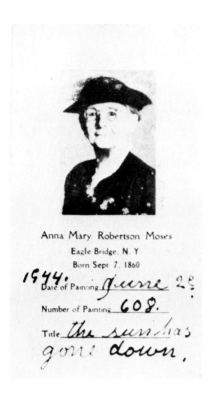

Anna Mary Robertson Moses
Eagle Bridge, N. Y
Born Sept. 7, 1860

1944.

Date of Painting *June 28.*

Number of Painting *608.*

Title *the sun has gone down.*

GRANDMA MOSES
Anna Mary Robertson Moses

Date of Painting *Oct 12, 1955,*

Number of Painting *1695,*

Title *September.*

The copyright of this painting is the property of
GRANDMA MOSES PROPERTIES, Inc.
46 West 57th Street, N. Y. C.

140–41. Labels used by Grandma Moses
on her pictures (original size)

records, he put headings on the first few pages (plates 138, 139).

Record Book entries for the years 1941–45 reflect a period of exuberant activity. Grandma Moses found herself suddenly popular, her work in great demand. Requests came in the mail and from travelers who made a detour through Eagle Bridge to buy a painting directly from the artist. Many pictures dating from this period were not recorded in her book.

At this time, Grandma Moses began noting more frequently the amounts for which she sold her pictures. A comparison of prices with dimensions indicates that she priced them according to size. On page 18 (1943), for example, a picture measuring 6¼ by 8 inches is listed as having been sold for $2; one measuring 11½ by 13¾ inches brought $5; and one 23 by 26¾ inches brought $15.

It is not possible to establish at what point Grandma Moses began to put numbers on her paintings. The logic of her early system of numbering defies analysis. The first pictures on which numbers appear were painted in 1941 but bear such numbers as 2010, 202, 2211! A painting dated February 9, 1942, is numbered 9, while in January of that year she used 29 and 199. Such discrepancies also appear in the Record Book. On page 24 the number 469 is followed by 500; on pages 31–32 there is a jump from 808 to 1000; on page 35 Grandma Moses "progressed" from 1099 to 1010, but on page 39 from 1099 to 1100.

However, from page 39 (that is, following 1945) up to the last painting, entries were made in a quite systematic manner. After 1955 they were written by Mrs. Winona Fisher and, after Mrs. Fisher's death in 1958, by Forrest Moses.

At about the same time that Fred Robertson gave Grandma Moses the Record Book, he also presented her with labels to paste on the reverse side of her pictures. On these labels she was to enter date, number, and title. When the supply of labels ran out in 1950, new ones were printed (plates 140, 141). In later years the new type of label was filled in by Mrs. Fisher and by Forrest Moses.

A catalogue and index of all works by Grandma Moses known to me is included in the book *Grandma Moses,* published in 1973 by Harry N. Abrams, Inc., New York. Altogether, nearly 1600 pictures have been recorded which the artist created in the course of about thirty years.

Evolving Her Own Style

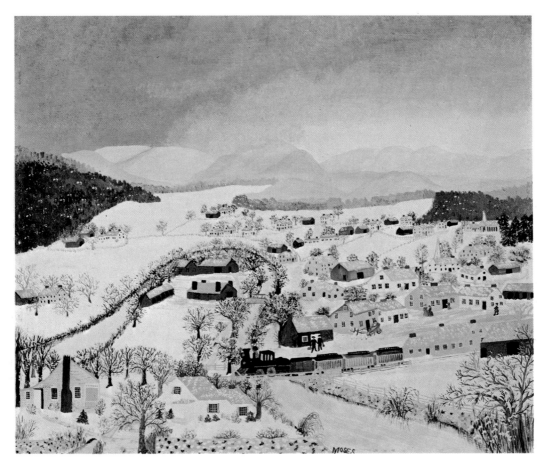

142. *Hoosick Falls, N.Y., in Winter.* 1944. 20 x 24″. The Phillips Collection, Washington, D.C.

GRANDMA MOSES HAS BEEN CALLED a "primitive" painter, a term generally applied to artists who have had no professional training. She shared with other so-called "primitives" a naive and almost childlike approach to her subject, not worrying whether she would be able to solve a problem with the artistic means at her disposal. However, as her technical ability progressed and developed, so did her gifts as a painter, and she achieved works which far outrank what one is wont to label "primitive." It cannot be said of many artists—whether professional or self-taught— that they have created a distinctive style of their own, as has Grandma Moses.

The artist's work is basically concerned with one theme: life on the farm and in the country. But on closer study, it reveals an astonishing variety of treatment and subject matter.

Landscapes

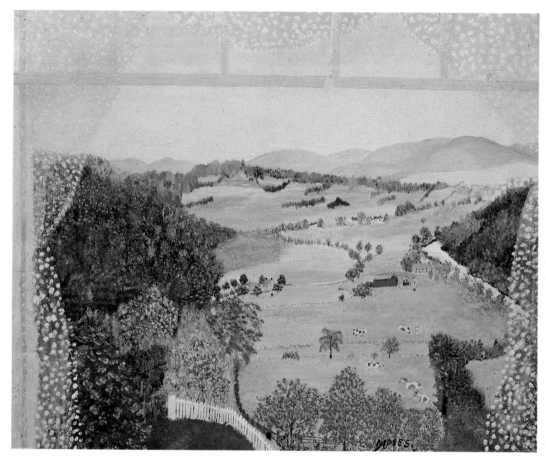

143. *Hoosick Valley (from the Window)*. 1946. 19½ x 22″. Private collection

MOST OF HER PAINTINGS ARE LANDSCAPES, often depicting the countryside where New York borders Vermont. This is "Grandma Moses Country," the region she knew and loved for a lifetime, where year after year she watched the passing of the seasons. This landscape often forms the setting for the specific events and activities she pictured. Towns, villages, and particular buildings in the area that had played a role in her life—Bennington, Hoosick Falls, Williamstown, the schoolhouse in Eagle Bridge, the Whiteside Church—became her subjects.

She attained the highest artistry in some of the pure landscapes, such as two works that represent the countryside as she saw it from her house: *Hoosick Valley (from the Window)* and *Hoosick River, Winter* (plates 143, 146). The one depicts a spring day, with fruit trees in bloom. There is no "action," the barely indicated figures of grazing cattle only serving

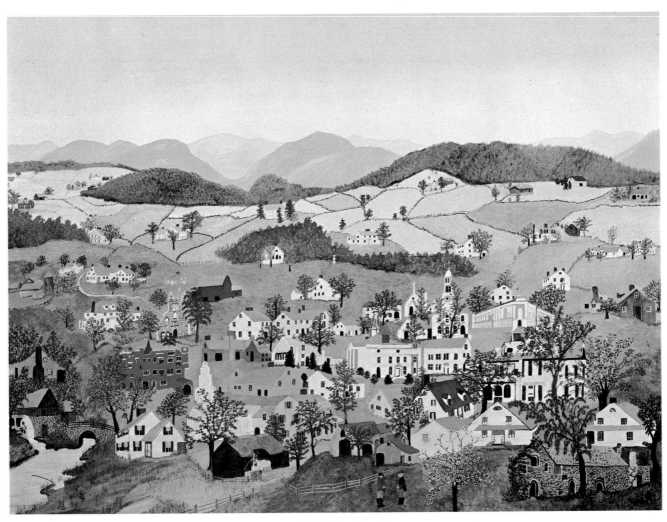

144. *Williamstown.* 1946. Canvas, 36 x 48″. Collection Mrs. Rockefeller Prentice

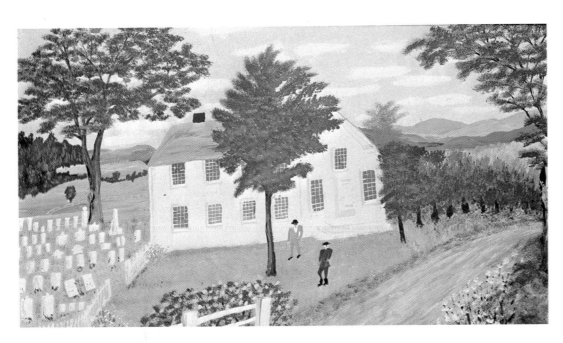

145.
The Whiteside Church.
1945. 9¾ x 17″.
Private collection

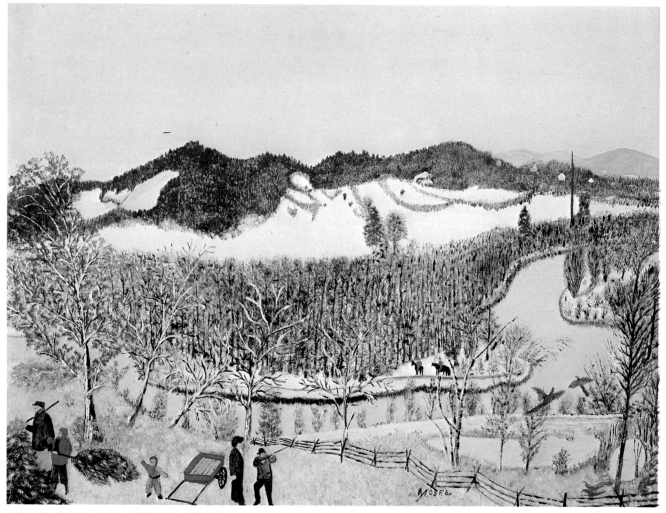

146. *Hoosick River, Winter.* 1952. 18 x 24″. Private collection

to emphasize the tranquillity of the scene framed by the window and its white-dotted net curtains. In *Hoosick River, Winter* the cold starkness of a winter's day is simply and beautifully rendered; the frozen river is seen between snow-covered fields and bare trees; the distant hills are gray. The hunters in the foreground underscore the mood. The stillness of winter is upon the land.

The landscape of Virginia, where the artist lived in her early married years, was equally dear to her. She frequently painted "that beautiful Shenandoah Valley" and the various places where she and her husband had lived and raised their children.

Apple Butter Making (plate 147) evokes a recollection from this time. It is set in the orchard and meadows of the "Dudley Place" near Staunton, Virginia, where the family lived for eight years. "Just a common farm,"

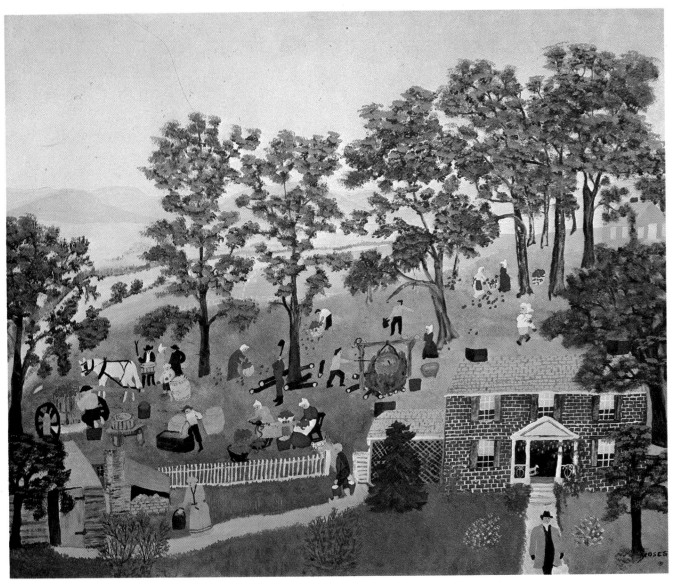

147. *Apple Butter Making.* 1947. 19¼ x 23¼". Galerie St. Etienne, New York

she later described it. The large house in the foreground at the right can
be identified as the family's actual abode; a photograph that Grandma
Moses kept shows a house almost identical with the one in the picture.
This work is interesting both in its well-planned and tidily executed
composition—the many people, each busy with a particular chore, are
in correct proportion to their surroundings—and in its color scheme of
predominating greens and reds. The chief color accent is provided by
the meticulously painted red-brick house with green shutters and a white
portico. A kettle for boiling down the cider and apples hangs over an
open fire in the orchard. In spite of the importance of the house, the
circular spot of fire is, so to speak, the heart of the painting, because of

its concentration of color and its decisive part in the process of the work. Beyond a faintly visible white fence in the background is the river bank. Here, as in so many of the artist's pictures, trees play an important role; she loved them especially and observed their various shapes and tones. In this summer painting they are bushy with abundant deep-green foliage. There is an interesting detail in the left foreground: the figure of a woman dressed in a gown of pale mauve, a color that does not otherwise appear in the painting. It is said that Grandma Moses sometimes used this color when she put herself into a picture.

Between 1943 and 1950, Grandma Moses created about twenty very large paintings measuring up to 36 by 48 inches. She was first encouraged to venture into this format by Ala Story, who sent her two large canvases in the summer of 1943 and suggested that she paint two winter scenes. The bedroom in which Grandma worked in the "old home" was far too small to accommodate a large table or easel; she

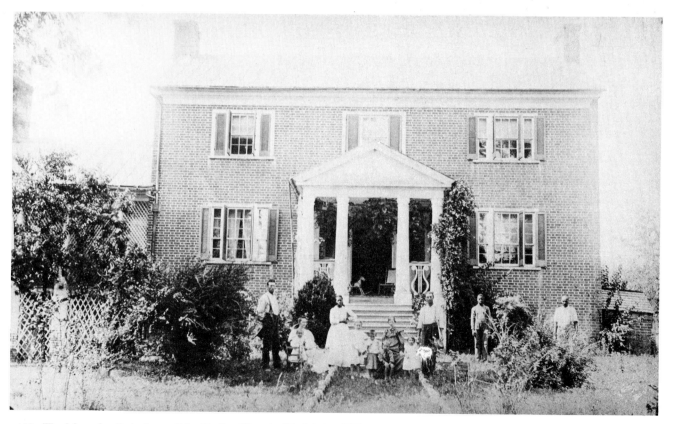

148. The Moses family in front of the Dudley Place in Virginia, c. 1892

therefore had to lay the canvases on her bed while painting—a strenuous procedure for a woman in her eighties. She first did a painting of a winter landscape, *Over the River*, and then, instead of another snow picture, *Checkered House* (see plate 38). During the following years, Mrs. Story sent her more large canvases. In between, the artist also did several paintings of similar size on Masonite board, her favorite material ("it will last longer").

Considering that only a few years earlier Grandma Moses's first timid attempts had been small paintings in which she depicted specific objects and narrowly defined scenes, one cannot but be amazed at the daring and confidence with which this very old woman undertook the task of painting such large pictures. They are freely and harmoniously composed, giving full scope to her imagination, and they rank among her very best.

A number of them deal with themes the artist had taken up formerly in smaller pictures, but the large versions never give an impression of being empty, artificially enlarged, or "filled in" to make use of the greater space. Sometimes the large canvas is a summing up of many previous artistic experiments and achievements, as for instance *Grandma Moses Going to Big City* and *Grandma Moses's Childhood Home* (plates 149, 150). These two works are especially interesting for the sense of rhythm they convey.

In *Grandma Moses Going to Big City,* the very accurately rendered compound of the Moses farm is circled by a country road leading from in front of the buildings into the background. A driveway goes up to the house and on it there is the old car that will take Grandma to the railroad station. This beautifully composed painting, in which everything is in perfect proportion, is, by the way, another example of an incidental scene that gives a picture its title.

In *Grandma Moses's Childhood Home* the rhythm is especially marked. Two wide circles formed by roads surround buildings, meadows, and orchard; they are linked by a large barn in the center.

Out for Christmas Trees (plate 151), painted on Masonite, is one of the artist's most popular and frequently reproduced pictures. It is the ideal example of a "Grandma Moses" if one has come to think of her mainly as an artist of the winter scene. Strong and simple, it is painted in tones of white and deep green. Among the clusters of fir trees a few tall trees that have shed their foliage stand out, their bare, snow-covered branches

149. *Grandma Moses Going to Big City.* 1946. Canvas, 36 x 48″. Private collection

150. *Grandma Moses's Childhood Home.* 1946. Canvas, 36 x 48″. Collection Alfred J. Ostheimer III

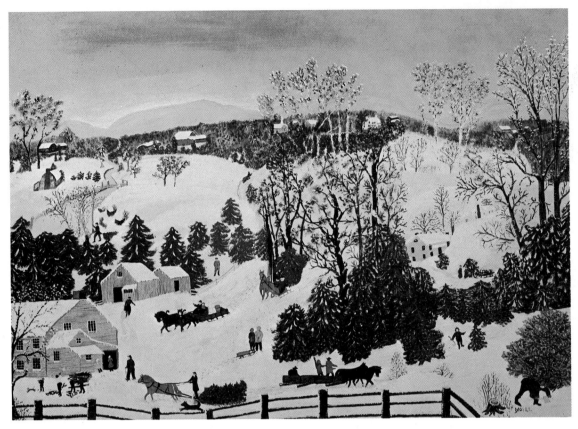

151. *Out for Christmas Trees.* 1946. 26 x 36″. Private collection

silhouetted against a gray sky. Horse-drawn sleighs are arriving or leaving; the movement of the animals is masterfully observed. The figures are comparatively small and do not detract from the overall atmosphere of a winter landscape. There is a typical tiny "aside": a small boy stands beside a little fir tree, no taller than himself, probably intending to chop it down and carry it home for his own.

The Barn Dance and *Country Fair* (plates 152, 153), which show a wealth of charming detail integrated into the surrounding landscape, are the last large paintings Grandma Moses created. She was nearly ninety at the time, and conceded that the physical strain was getting to be too much for her. From then on she returned to smaller pictures.

While the majority of Grandma Moses's landscapes are static and show nature in a mood of undisturbed peace, she also did a number in which it is in a state of turmoil. A disturbance in the atmosphere is generally represented by windblown trees bending under a gale and, as in her blizzard and thunderstorm pictures, by a sky dark with menacing clouds. People and animals hurry for shelter, frightened and helpless before the forces of nature.

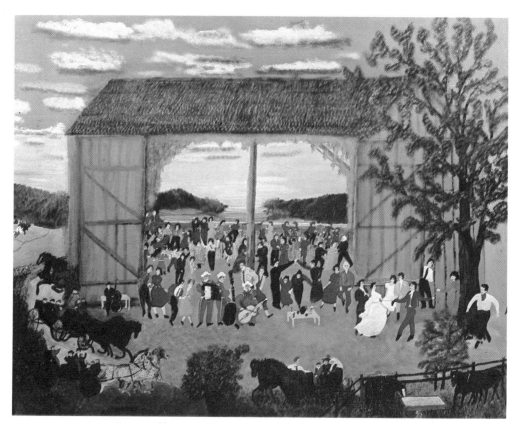

152. *The Barn Dance.* 1950. Canvas, 35 x 45″. Hammer Galleries, New York

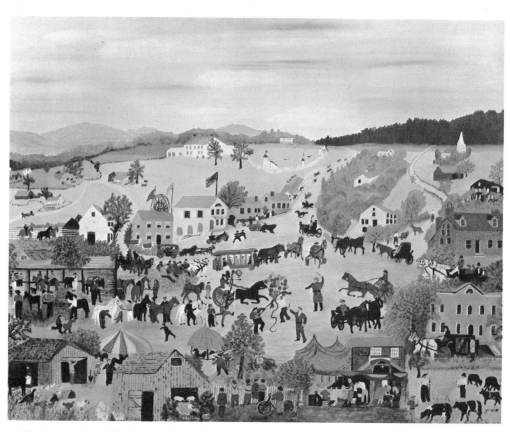

153. *Country Fair.* 1950. Canvas, 35 x 45″. Collection David H. Griffin

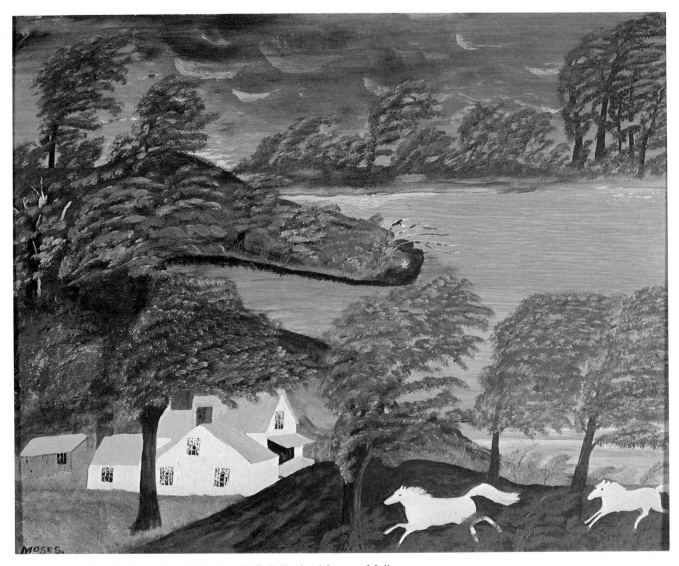

154. *A Storm Is on the Waters Now.* 1947. 16 x 20¼". Collection Margaret Mallory

A Storm Is on the Waters Now (plate 154) is a powerful, almost eerie evocation of impending danger. Under a black sky and past dark, storm-tossed trees, two white horses gallop in terror toward a white house, conveying a mood of inescapable violence in an almost Surrealist fashion.

Taking in Laundry (plate 155) is not quite so dramatic. It shows people busy salvaging their day's work before the oncoming storm, but still able to cope with nature.

Another painting that depicts commotion, though not in a threatening way, and that stands out for its subject matter, composition, and imagination is *Halloween* (plate 156), painted in 1955. It records the many activities characteristic of that particular October night. Barrels

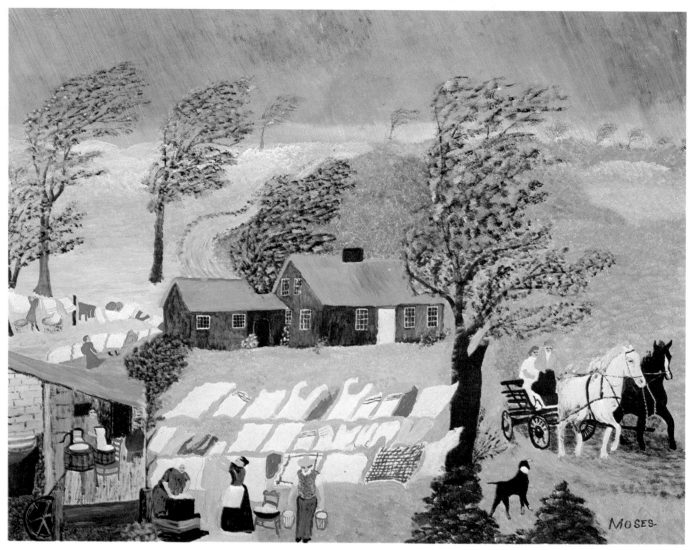

155. *Taking in Laundry.* 1951. 17 x 21¾". Private collection

of cider and buckets of harvested apples are being prepared for the customary apple dunking, which has already begun inside the house. Jack O'Lantern pumpkins glow in the dark—for it is evening, with a pale moon beginning to shine. There seem to be goblins everywhere, or just boys playing all kinds of tricks. The children are running around, either to admire the pumpkins or because they are scared. Little white faces pop up, it is not clear whether of ghosts or real people. The wildest pranks are going on on the roof, where a cart is being rolled back and forth to make uncanny noises in the house below. Two tiny yet very conspicuous "witches" seem almost to float in mid air, little white phantoms quite other-worldly in the midst of robust country folk. The colors of the painting are strong and warm, especially in the foreground:

156. *Halloween.* 1955. 18 x 24″

rich tones of red, brown, and dark green; a view into the house shows a
blazing fire in a red brick fireplace. This vivid detail is counterbalanced
by a group of men unloading barrels from a horse-drawn cart; the
simplicity and strength with which the artist has shown them is remi-
niscent of Bruegel. A white fence in the very foreground closes in the
manifold lively scenes. Gradually, as they fade into the background, the
colors become more subdued: gray houses and dark, distant hills, and
finally, above all the commotion, a quiet, cold wintry sky. The com-
position of this remarkable painting is unified and softened by the tall
trees, their yellow autumn foliage spreading, as it were, a delicate veil
over the bustling life below.

Interiors

SOMETIMES THE ARTIST WOULD DEVIATE from her familiar path. She was not satisfied with painting only what the public had come to expect. Time and again she tried to tackle problems that posed a challenge, as though to prove to herself that she could still learn and progress. Such experiments often resulted in extraordinary achievements. She continued to the very last her earnest endeavors at "improving" instead of just making it easy for herself. This seems all the more remarkable since people did everything they could to make her repeat what had led her to fame.

One of the problems she tried to cope with was interiors. Some customs and festivities that she remembered demanded an indoor setting. The artist was aware that her scant knowledge of perspective and her inadequacy in depicting human figures were more evident in such paintings than in her landscapes. She wrote in a letter to a friend: "I tryed that interior but did not like it so I erased it, that dont seem to be in my line. . . . Well maybe I try again." In spite of these difficulties she actually did more than twenty interiors in the course of the years.

One of the earliest was *Christmas at Home* (plate 157), painted in 1946. In order not to omit anything that goes into the celebration of a joyful family Christmas, Grandma Moses made the room far larger than it would be in an average farmhouse. It easily accommodates a huge Christmas tree, two tables in the foreground festively decked in white and laden with refreshments, a fireplace flanked by two windows in the center of the back wall with two elderly men seated in front of it. There are some two dozen figures in this lively and cheerful picture, old and young, besides a baby in a cradle, two dogs, a cat, and Santa Claus himself bringing in packages. Even the doorway is not deserted—a boy is about to enter with logs for the fire. This painting, eminently naive, is filled with the joy of storytelling, every detail a beloved experience and memory.

Another interior, *The Quilting Bee* (plate 158), painted in 1950, is remarkable both for its folkloristic content and its composition. Here is Grandma Moses's description of the custom:

> Back in Revolutionary War times quilting bees were a necessity as well as a thing of art. The women took great pride in their needle work. Every well regulated house had one room set aside which was

157.
Christmas at Home.
1946. 18 x 23″.
Collection Mrs. F. Kallir

158.
The Quilting Bee.
1950. 20 x 24″.
Private collection

called the quilting room; the quilting frames were set up on the backs of chairs or stands. The women of the neighborhood would gather to sew, sometimes at night, but candle light was very poor for fine stitches, which the women of those days prided themselves in. Some of the designs were beautifully done, such as the Sunflower, Rising Sun and Friendship, where each one wrote her name in the center of the block. There are a few of those old quilts scattered through the country, highly cherished by their owners.

This interior is composed in a somewhat more sophisticated way than *Christmas at Home*, yet the overall appearance is that of a "primitive" painting. Whereas in the earlier work the figures and objects seem scattered around to fill in any space, *Quilting Bee* is clearly divided into three planes—background, middle ground, and foreground. Here, too, the room is very large, almost a hall, with three windows and the indication of a beamed ceiling. The windows look out onto a landscape of delicate hues—the ones in *Christmas at Home* are dark, indicating that it is night. The main activity takes place in the upper center of the picture, where a large frame bears a many-colored quilt on which eight women are working. To the left stands an old-fashioned iron cooking stove with busy women around it. In the foreground a table with a white cloth is set for the meal. The composition of a picture with two almost equally large areas placed parallel to each other might have become clumsy, but the artist has successfully solved the problem by loosening up the composition with many incidental figures and by showing a fairly wide amount of floor space between the furnishings of the room. The general impression is one of almost stylized order with the colorful quilt forming the focal point.

Views out of windows, as seen in this painting, were themes occasionally taken up by the artist. They might show a sunny landscape, or indicate the night outside, or be "blind," giving a shut-in impression. Once in a while she would combine the view into a house with the surrounding landscape or give glimpses into rooms as though the fourth wall had been opened up, like a doll's house. Examples can be found in the paintings for *The Night Before Christmas*.

Perhaps Grandma Moses's two most unusual interiors are the pictures *In the Studio* (plate 159), done in 1944, and *Rockabye* (plate 160), painted thirteen years later, in 1957. In both of them she attempted self-portraits, to my knowledge the only ones she ever did. Though she quite often included herself among the figures populating a scene—carrying

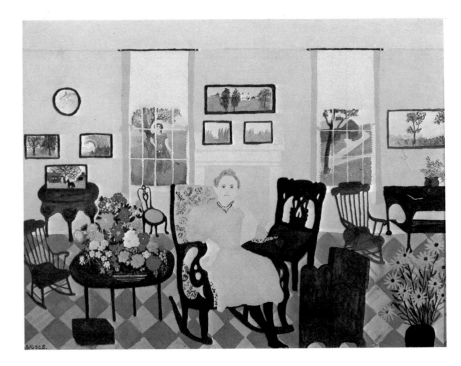

159.
In the Studio.
1944. 18 x 23½″.
Sidney Janis Gallery, New York

a milk pail, standing in a doorway, or about to enter a carriage—these are always featureless representations.

Since the subject had not appeared in her work before, it is very likely that she painted the first picture at the suggestion of a friend, coping with the theme as best she could. The artist was certainly too modest and not introspective enough to consider doing a self-portrait for its own sake. She is therefore surrounded by many objects of her daily life—her own small paintings decorate the walls, a huge and colorful flower arrangement stands on the table to her right, a vase with tall black-eyed susans in a corner on the floor. Two large, partly curtained windows in the rear are like pictures in themselves, one giving a view of the garden with a girl beneath a tree, the other of a path leading up to one of the familiar red barns. Grandma occupies the center of the scene, seated in a wide rocking chair, yet she seems to have lavished more care on the objects in the room than on herself. Her dress is plain and unadorned, while even the upholstery of the chair shows a design. The pale gray of the dress contrasts with the strong tones of flowers and dark heavy furniture. It is interesting that she is not wearing the glasses to which she was accustomed at that time—her eyes, two dark dots, look out at the beholder in an almost uneasy way.

Rockabye, the later, far smaller painting, reveals more of the artist's personality. In contrast to the almost cluttered appearance of the earlier picture, here the setting is a rather bare living room. Grandma,

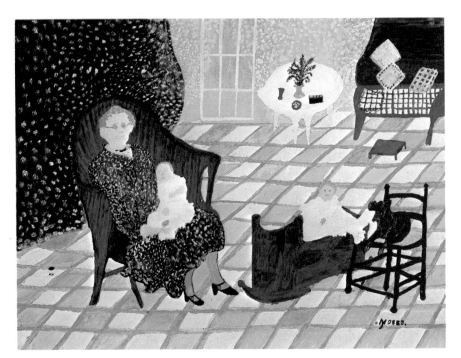

160.
Rockabye.
1957. 11⅞ x 16″.
Private collection

seated to the left in a wicker chair, dominates the composition. A dark-green curtain with white dots provides a lopsided but very effective background. It is touching to note the accuracy and detachment with which Grandma Moses saw herself. There she is, the little frail old lady, as others may have seen her, with no embellishment, no softening light. She is wearing her familiar black-and-white print dress, there is a narrow black ribbon around her neck, and her gray-stockinged feet and very characteristic shoes are side by side, a bit apart, in a not too graceful but most realistic way.

The features of Grandma's face here, too, are not very marked and her glasses, clear and sparkling in real life, are strangely dim and opaque. She is holding a baby on her lap, but in an unconcerned manner which perhaps reflects her matter-of-fact and totally unsentimental attitude. There is a second child in a cradle to the right; nearby, a chair with a dog; toward the back, a table with trinkets and a settee with cushions. More striking than these is the carefully drawn linoleum that covers the floor in a pattern of dark and light squares outlined in green.

There is a window in the back, but it, like Grandma's glasses, is "blind" and permits no view to the outside. If one were tempted to interpret this work psychologically, one might say that it conveys a sense of both calm and resignation. The very old woman and the tiny new human being—a circle of life that has come full way around.

Last Paintings

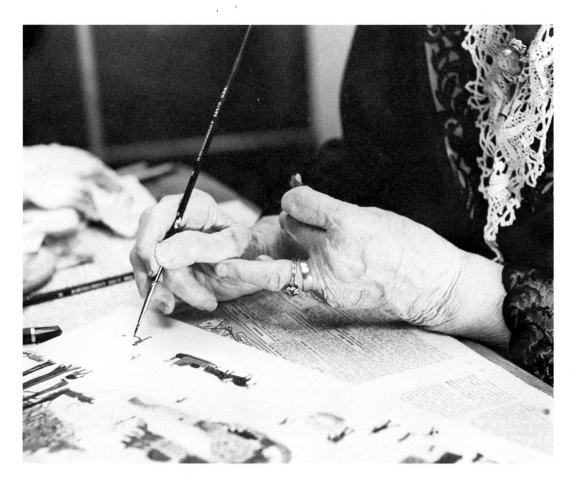

161.
The hands of
Grandma Moses

THE ARTIST RETAINED THE STEADINESS OF HER HAND into her very old age. Supporting her right hand with the left, she would fill in with absolute accuracy the finest details, such as window slits in distant small buildings or the eyes in human faces. Then gradually, toward the end of 1959, some of her pictures show a changed way of painting whereby the subject matter is almost dissolved into color. This can be observed in *Autumn Leaves* and *Last Snowfall* (plates 162, 163), painted when she was ninety-nine, and in *Falling Leaves* (plate 164), *The Deep Snow*, and *Vermont Sugar*, painted in the last year of her life. There are, of course, human figures, barns, fences, and even a cart or two in these pictures, but they are more roughly daubed in, as though—which may well have been the case—the artist had become impatient with detail and mainly wanted to bring out the general impression of a nature scene, whether the yellow leaves of autumn or the softly falling snow.

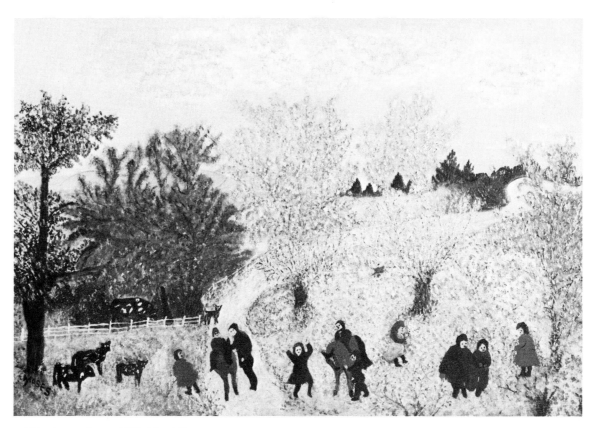

162. *Autumn Leaves.* 1959. 16 x 24″

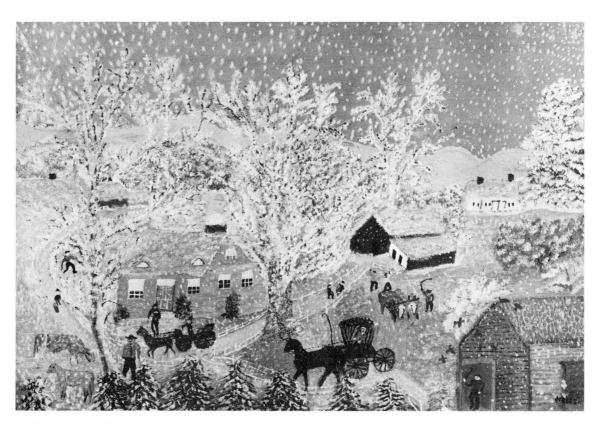

163. *Last Snowfall.* 1959. 16 x 24″

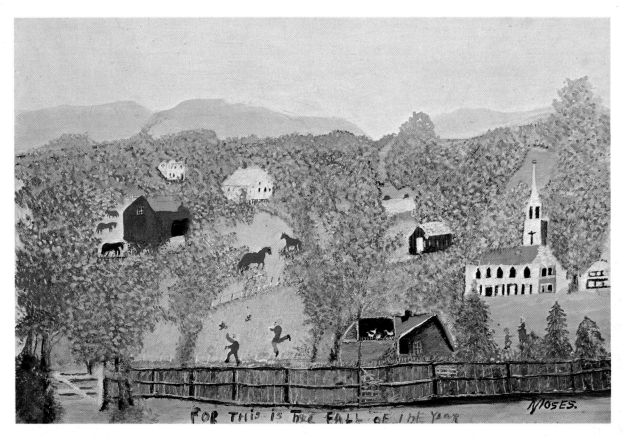

164. *Falling Leaves.* 1961. 16 x 24″. Collection Walter K. Rush

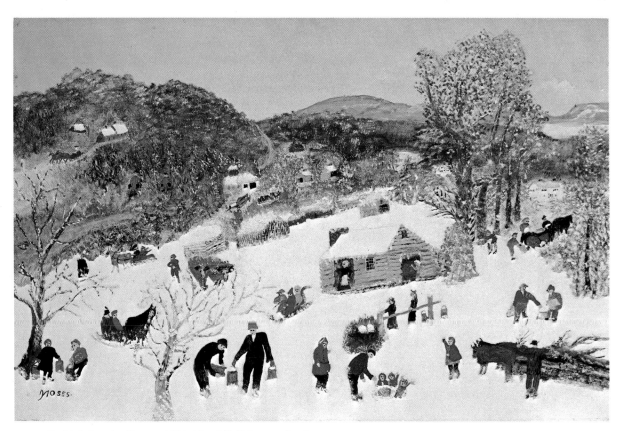

165. *Untitled: Sugaring Scene.* c. 1961. 16 x 24″. Private collection

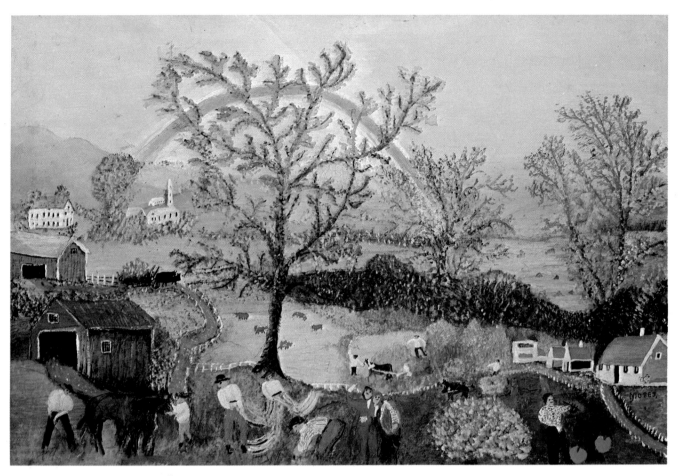

166. *Rainbow.* 1961. 16 x 24"

Grandma Moses gave the title *Rainbow* to the very last picture she completed (plate 166). Its label bears the number 1997 and the date June 1961. After Grandma Moses's death, Emily Genauer wrote about this painting in the *New York Herald Tribune* of December 14, 1961:

> The pale rainbow she lightly sketched in that picture, arching over a lush summer landscape of her beloved Cambridge Valley . . . will never be strengthened now, as she had planned to strengthen it. No matter. It will remain a strong enough span for those looking at it—or, indeed, at any of her pictures—to be able to reach her simple, peaceful, idyllic nineteenth-century world from their own frantic world of today.
>
> A span leading only to escape need not be strong. Nostalgia and dreams are stout enough materials for its fashioning. But Grandma Moses' span was made of faith. So strong was her own, so certain her conviction that the earth and all growing things . . . are proof that there *is* a meaning to life, that somehow, looking at her pictures we are reassured.

Epilogue

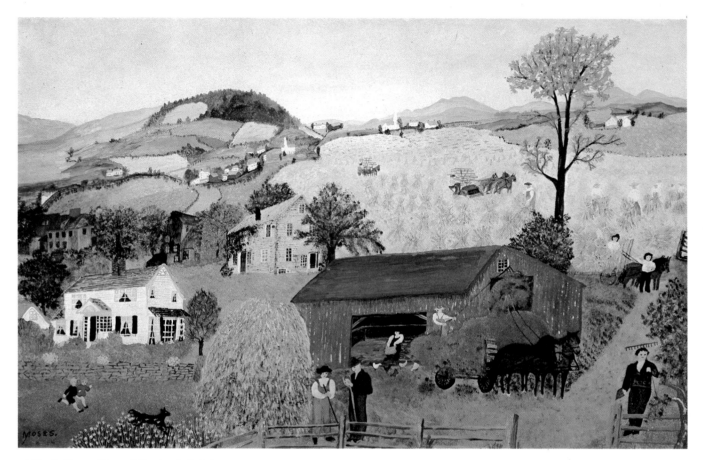

167. *In Harvest Time.* 1945. 18 x 28″. Private collection

THE WORLD OF GRANDMA MOSES is bright and serene; man is in perfect harmony with nature, the tasks he performs are dictated by the daily necessities of farm and country life, as unquestionable as rain or sunshine. Nowhere is there a sign of overwhelming toil; nothing is either good or bad, everything is natural. If Grandma Moses permits herself any personal slant, it is expressed by her strong and charming sense of humor. Mischief of any kind is always good-natured fun—the *Halloween* picture is full of it.

When the artist, departing from the serenity that emanates from most of her paintings, does represent a disturbance, it is not man-made but springs powerfully from nature, as in her representations of stormy and windswept landscapes.

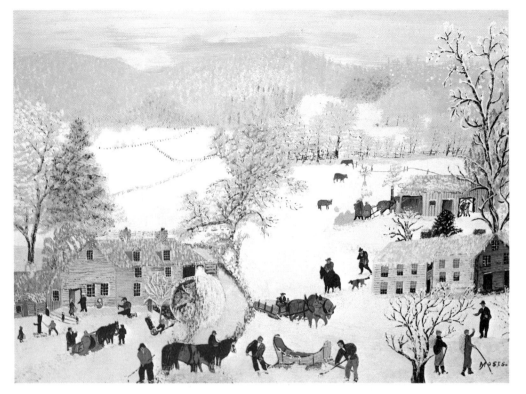

168. *A Frosty Day.* 1951. 18 x 24″. Private collection

169. *A Frosty Day* (detail)

170.
Green Sleigh.
1960. 16 x 24″

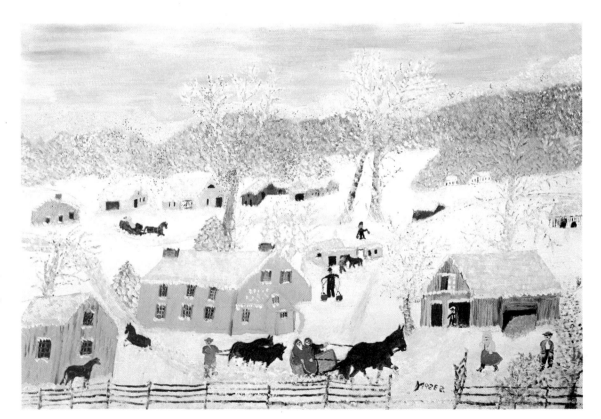

Never could she have re-created the beauty of a landscape, the changing seasons, the activities that they entail—plowing, haying, harvesting, sugaring—had she not deeply felt and loved nature in all its aspects and varying moods. But it would not have occurred to her to represent them for their pure aesthetic value or to "romanticize" a scene. She painted what she saw and intimately knew, and the beauty which radiates from her work is the natural result of her vision.

No doubt some present-day critics find the world of Grandma Moses too simple, too unproblematic, lacking in the awareness of the strife and grief that overshadow our lives. Although she certainly had experienced them, what she expressed in her art are the everlasting sources of vitality from which man draws his strength, courage, and hope. She has shown an image of her country far different from what has come to be regarded as "typically American," and the image is truer and more enduring.

Jean Cassou, the former director of the Musée National d'Art Moderne in Paris, one of the foremost European authorities on modern art, has expressed most concisely and beautifully what Anna Mary Robertson Moses's work means to the world of art and to our time. He wrote on the occasion of the artist's hundredth birthday:

> The Primitives are the salt of the earth. Through their existence alone does contemporary art, so knowing, so sophisticated and daring, preserve in its depth sources of freshness and life. Thus the Cubists had at their side the Douanier Rousseau, and their marvelous intellectual speculations were counterbalanced by the companionship of this pure heart, inspired by the genius of the people and of nature. The United States through its "avant-garde" is making the most daring aesthetic experiments, but also has its primeval forces, its springs of fresh water. From her small-town vantage point, the adorable Grandma Moses comes to the defense of the countryside, the empire of foliage and birds, and upholds the rights of nature. She would have us know that there is still a bit of paradise left on this earth and that art may reach out as far as it will with its most advanced branches, because it is deeply rooted in the rich soil of Grandma Moses's garden.

"How Do I Paint?"

171. Grandma Moses's painting table

EagleBridge April 7th 1947.

How do I Paint?

well first I get a frame, then I saw my
masonite board to fit the frame.

Then I go over the board with Oil,
Then give the board three coats of flat
white paint,

Now it is ready for the scene, what
ever the mind may produce,

A land scape picture, an Old Bridge A
Dream, or a summer or winter scene,

Child hoods memory, what ever one fancys,

But always somthings pleasing and
cheerful and I like bright colors and
activity,

why do I use masonite or hard wood
to paint on?

Becaus it will last many years longer
than canvas,

Some times the frames are hard to
obtain, they may be pretty frames but
in a delapidated condistion,

Then I must use hammer and nails with plastics, the frames should allwise blend with the painting for best affect,

why did I start to paint in my old age?

well to tell the truth, I had neueritus and artheritus so bad that I could do but little work, but had to keep busy to pass the time away, I tryed worsted pictures, then tryed oil,

and now I paint a great deal of the time,

It is a very pleasant Hobby if one does not have to hurry,

I love to take my time and finish things up right,

At first I painted for pleasure, Then I was called upon to do more than I could, to live up to my promises,

when I first commenced to paint with oil, I thought every painting would be my last one,

So I was not so interrested,

Then the reywerts commenced to come, from this one and that one,

"Paint me one just like that one"
So I have painted on and on till now,

Those that I have keept track of are "77.

But that is not all of them,

I think I'm dowing better work then at first,

But it is owing to better brushes and paint,

I don't advise any one to take it up as a buisness proprosition, unless they really have talent, and are crippled so as to deprive them of physical labor,

Then with help they might make a living,

But with taxes and income tax there is little money in that kind of art for the ordinary artis

But I will say that I have did remarkable for one of my years, and experience,

thanks to mr Louis Coldor, mr Otto Kallin and alla Story, through those, life has been a Success,

As for publicity, that I'm too Old to care care for now,

Some times it makes me think of a dream that my Father once told at the breakfast table one morning many years ago,

He said, "I had a dream about you last night anna mary"

was it good or bad Pa,?

And he said that depends on the future, Dreams cast their shadows before us,

He dreamed, I was in a large Hall and there were many people there,

They were claping their hands and shouting, and I wondered what it was all about, and looking I saw you anna mary coming my way, walking on the shoulders of men, you came right on steping from one shoulder to another waving to me,

Of late years I have often thought of that dream, sience all the publicity about me, an of Mother saying, to Father,

"Now Russell anna mary would look nice walking on mens sloulders"!

She saw the folly of that dream,
Or did she? did that dream cast its shadows before?

I often wonder, now that I'm getting letters from all most every country on the Globe,

and such kind wellwishing letters, and they come to Grandma from faraway,

I love to have visitors, they are awlwise walcomed, and they bring in news of the owter world, which is realy delightful,

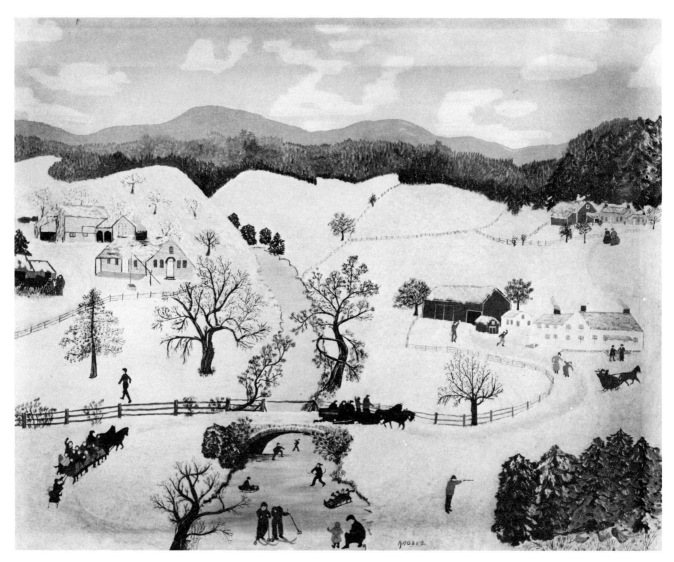

172. *Over the River*. 1943. Canvas, 34 x 45″. Collection Mrs. Jack Kapp

Biographical Outline

1860 September 7, Anna Mary Robertson is born in Greenwich, N.Y.

1872–87 Works as a hired girl on neighboring farms.

1887 November 9, marries Thomas Salmon Moses.

1887–1905 Lives and farms in Virginia. Ten children are born, of whom five die in infancy.

1905 Returns to New York State; purchases a farm in Eagle Bridge.

1909 Her mother dies in February, her father in June.

1918 Paints her first large picture, on the fireboard in her parlor.

c. 1920 Paints landscapes on the panels of her "tip-up" table and occasional pictures for relatives and friends.

1927 January 15, Thomas Salmon Moses dies.

1930s Lives in Bennington from about 1930. After the death of her daughter Anna Moses in February 1932, she cares for two grandchildren. Embroiders "worsted" pictures. Returns to Eagle Bridge in 1935. Begins to paint in earnest. Exhibits pictures along with preserves at country fairs.

1938 Exhibits pictures in Thomas's Drugstore, Hoosick Falls, N.Y., where Louis J. Caldor discovers them.

1939 October 18 to November 18, three paintings are included in a show of "Contemporary Unknown American Painters" in the Members' Rooms of the Museum of Modern Art, New York.

1940 October 9, the opening of her first one-man show, titled "What a Farm Wife Painted," at the Galerie St. Etienne, New York. In November, visits New York to attend an exhibition of her work at Gimbels Thanksgiving Festival.

1941 New York State Prize is presented to her for *The Old Oaken Bucket* at the Syracuse Museum of Fine Arts (now the Everson Museum of Art).

1946 Publication of *Grandma Moses: American Primitive* by Otto Kallir, with an introduction by Louis Bromfield and autobiographical notes by Grandma Moses. The first Christmas cards reproducing her paintings are published.

1949 In February, her youngest son, Hugh, dies. In May, the Women's National Press Club Award, "for outstanding accomplishment in Art," is presented to Grandma Moses by President Harry S Truman in Washington, D.C. In June, she receives an Honorary Doctorate from Russell Sage College, Troy, N.Y.

1950 Erica Anderson creates a documentary color film, with narration by Archibald MacLeish.

1951 Grandma Moses receives an Honorary Doctorate from the Moore Institute of Art, Philadelphia.

1952 *My Life's History* by Grandma Moses is published.

1953 Grandma Moses is guest speaker at the *New York Herald Tribune* Forum in New York.

1955 Edward R. Murrow interviews Grandma Moses for a telecast in his "See It Now" series.

1958 October 14, her daughter Winona Fisher dies.

1960 Paints pictures illustrating *The Night Before Christmas*, by Clement C. Moore.

1960, 1961 Governor Nelson A. Rockefeller proclaims the artist's birthday "Grandma Moses Day" in the State of New York.

1961 In June, paints her last picture, *Rainbow*. December 13, Grandma Moses dies at the Health Center, Hoosick Falls.

Selected Bibliography

Grandma Moses by Otto Kallir. The story of her life and work. With the catalogue of her pictures. Harry N. Abrams, Inc., New York, 1973.

BOOKS WRITTEN OR ILLUSTRATED BY GRANDMA MOSES
(in chronological order)

Grandma Moses, American Primitive. Edited by Otto Kallir. Introduction by Louis Bromfield. Comments on forty paintings and a brief autobiography by Grandma Moses. First edition: Dryden Press, New York, 1946. Second edition: Doubleday & Co., Garden City, New York, 1947.

Christmas. Facsimile edition of the handwritten manuscript. 500 copies. Galerie St. Etienne, New York, 1952.

My Life's History. Edited by Otto Kallir. Trade edition and a special autographed, numbered edition of 270 copies bound in half-leather. Harper & Row, New York, 1952. British edition: André Deutsch, London, 1952. German edition: *Meine Lebensgeschichte.* Ullstein Verlag, 1957. Dutch edition: *Het verhaal van mijn leven.* A. W. Bruna & Zoon, 1958.

Christmas with Grandma Moses. Phonograph record of Christmas music with commentary spoken by Grandma Moses. Paintings, photographs, and quotations from the artist's writings in the descriptive booklet bound into the record album. RCA Victor No. LOP–1009, 1958.

The Grandma Moses Storybook. Stories and poems by 28 writers. Edited by Nora Kramer. Illustrated by Grandma Moses. Biographical sketch of the artist by Otto Kallir. Random House, New York, 1961.

The Night Before Christmas. Clement C. Moore. With pictures by Grandma Moses especially painted for this book. Random House, New York, n.d. [1962].

CHILDREN'S BOOKS
(in chronological order)

Graves, Charles P. *Grandma Moses, Favorite Painter.* Garrard Publishing Co., Champaign, Ill., 1969.

Armstrong, William H. *Barefoot in the Grass: The Story of Grandma Moses.* Doubleday & Co., Garden City, New York, 1971.

BOOKS PUBLISHED DURING GRANDMA MOSES'S LIFETIME IN WHICH HER WORK IS DISCUSSED
(in chronological order)

Janis, Sidney. *They Taught Themselves: American Primitive Painters of the 20th Century.* Dial Press, New York, 1942.

Ford, Alice. *Pictorial Folk Art in America, New England to California.* The Studio Publications, Inc., New York & London, 1949.

Lipman, Jean, and Winchester, Alice. *Primitive Painters in America, 1750-1950.* Dodd, Mead & Co., New York, 1950.

Jasmand, Bernhard, and Kallir, Otto. *Sonntagsmaler: Das Bild des einfältigen Herzens.* Verlag Otto Aug. Ehlers, Berlin & Darmstadt, 1956.

Eliot, Alexander. *Three Hundred Years of American Painting.* Time, Inc., New York, 1957.

Bihalji-Merin, Oto. *Modern Primitives: Masters of Naive Painting.* Harry N. Abrams, Inc., New York, 1959.

REPRODUCTIONS
(in chronological order)

Series of 16 Christmas cards, 1946. The Brundage Company, New York.

Numerous Christmas and greeting cards, 1947-55; 1964-69. The Hallmark Company, Kansas City, Mo.

Four color reproductions, 1948-49. Besides the regular edition, 100 prints of each subject were numbered and signed by the artist. Two additional color reproductions were published in 1963 and 1965 respectively. Arthur Jaffe Heliochrome Company, New York.

"The Four Seasons." Set of four color reproductions, 1956. Donald Art Company, Port Chester, New York.

Series of 12 Christmas and greeting cards, 1957. R. Oldenbourg, Graphische Betriebe, Munich, Germany.

"Six of My Favorite Paintings." Portfolio of six color reproductions, 1959. Catalda Fine Arts, Inc., New York.

Portfolio of eight color reproductions, with an Appreciation by John Canaday, 1967. Art in America, New York.

Set of four color reproductions, 1973. Limited edition of 3000 numbered prints of each subject. American Heritage Publishing Company, Inc., New York.

PERIODICALS

An extraordinary amount of material has been published about Grandma Moses in newspapers and periodicals around the world. Some of the more significant articles published during the artist's lifetime are listed here in alphabetical order by author.

Fisher, Barbara E. Scott. "Go Ahead and Paint." *Christian Science Monitor Magazine,* January 5, 1946.

Grafly, Dorothy. "Primitive and Primitives." *American Artist,* October 1949.

Herbert, François. "Grandma Moses, 100 ans peintre." *Paris Match,* December 10, 1960.

Kutner, Nanette. "Grandma Moses: Norman Rockwell Talks About His Neighbor." *McCall's,* October 1949.

Lansford, Alonzo. "Grandma Moses." *The Art Digest* (now *Arts*), May 15, 1947.

Lipman, Jean. "Fourth of July Art." *Cosmopolitan,* July 1956.

Roden, Max. "Die amerikanischen Primitiven." *Die schönen Künste* (Vienna), 1947.

Schoenberg, Harold C. "Grandma Moses—Portrait of the Artist at 99." *The New York Times Magazine,* September 6, 1959.

Seckler, Dorothy. "The Success of Mrs. Moses." *Art News,* May 1951.

Soby, James Thrall. "A Bucolic Past and a Giddy Jungle." *The Saturday Review of Literature,* November 4, 1950.

Sullivan, Frank. "An Afternoon with Grandma Moses." *The New York Times Magazine,* October 9, 1949.

Stahly, François. "Grandma Moses/Morris Hirschfield." *Graphis* (Zurich), Vol. 7, No. 35, 1951.

Thompson, Dorothy. "The World of Grandma Moses." *Ladies' Home Journal,* January 1957.

Waldinger, Ernst. "Die Geschichte eines amerikanischen Erfolges." *Annabelle* (Zurich), March 1947.

Woolf, S.J. "Grandma Moses, Who Began to Paint at 78." *The New York Times Magazine,* December 2, 1945.

List of Major Exhibitions

1939 October 18–November 18
Contemporary Unknown American Painters: Opening Exhibition of the Advisory Committee of the Museum of Modern Art
The Members' Rooms, The Museum of Modern Art, New York. Included 3 paintings by Grandma Moses. Catalogue includes Introduction by Sidney Janis

1940 October 9–31
What a Farm Wife Painted: Works by Anna Mary Moses
Galerie St. Etienne, New York. 33 paintings, one embroidered picture. Mimeographed list of the pictures

November 14–25
Auditorium, Gimbels, New York. 50 paintings and embroidered pictures

1941 January
Whyte Gallery, Washington, D.C. One-man show of 26 paintings

May
New York State Art Show
Syracuse Museum of Fine Arts (now Everson Museum of Art), Syracuse, N.Y. Included 3 or more paintings by Grandma Moses (*The Old Oaken Bucket* received the N.Y. State Prize)

1942 February 9–March 7
They Taught Themselves: American Primitive Painters of the 20th Century
Marie Harriman Gallery, N.Y. Included 3 paintings by Grandma Moses. Catalogue with *A Statement by André Breton*

December 7–22
Anna Mary Robertson Moses: Loan Exhibition of Paintings
American British Art Center, New York. 32 paintings. Catalogue

1943 November
Grandma Moses
E.B. Crocker Art Gallery, Sacramento, Calif. 30 paintings

1944 February
New Paintings by Grandma Moses–The Senior of the American Primitives
Galerie St. Etienne, New York. 32 paintings

April 2–29
Grandma Moses – The Senior of the American Primitives
James Vigeveno Galleries, Los Angeles. 21 paintings. Catalogue

September 6–October 9
Syracuse Museum of Fine Arts (now Everson Museum of Art), Syracuse, N.Y. One-man show of 23 paintings

December
Grandma Moses
Galerie St. Etienne, New York. 36 paintings

1944–45 *Grandma Moses*
Traveling Exhibition: South Hadley, Mass.; Williamstown, Mass.; Amherst, Mass.; Nashville, Tenn.; Manchester, N.H.; Washington, D.C.; Dillon, Mont. 20 paintings

Portrait of America
Metropolitan Museum of Art, New York. Exhibition of 150 paintings conducted by Artists-for-Victory, Inc., presented in many leading museums in the United States after the New York show. Included one painting by Grandma Moses

1945 May 1–31
Grandma Moses: The Senior of American Primitives in Her Initial San Francisco Showing
Maxwell Galleries, San Francisco, Calif.

October 28–November 17
Recent Paintings by the Senior of American Primitive Painters: Grandma Moses
James Vigeveno Galleries, Los Angeles, Calif. 30 paintings. Catalogue

November 13–18
Women's International Exposition: Woman's Life in Peacetime
Madison Square Garden, New York. One-man show

1945–46 *Grandma Moses*
Traveling Exhibition: Utica, N.Y.; Norfolk, Va.; Claremont, Calif. 20 paintings

1945–49 *Painting in the United States, 1945*
Carnegie Institute, Pittsburgh, Pa. Each show included a different painting by Grandma Moses. Catalogues

1946 February 25–March 23
Exhibition of Paintings by Grandma Moses
The American British Art Center, New York. 44 paintings.
Catalogue

October 20–November 16
Recent Work by America's Beloved Grandma Moses
James Vigeveno Galleries, Los Angeles, Calif. 32 paintings.
Catalogue

1946–47 *Grandma Moses*
Traveling Exhibition: Manitowoc, Wis.; St. Paul, Minn.;
Lubbock, Tex.; Zanesville, Ohio; Ithaca, N.Y.; Lock Haven,
Pa.; Chicago, Ill. 20 paintings

1947 May 17–June 14
Grandma Moses: Paintings
Galerie St. Etienne, New York. 34 paintings. Catalogue
includes *How Do I Paint?* by Grandma Moses

1947–48 *Grandma Moses*
Traveling Exhibition: Rockford, Ill.; Beloit, Wis.; Raleigh,
N.C.; Cheltenham, Pa.; Abilene, Tex.; Lawrence, Kan.;
Baltimore, Md.; Waterbury, Conn. 20 paintings

1948 May 25–June 12
Thirty Paintings by Grandma Moses
The American British Art Center, New York. Catalogue
includes Introduction by Archibald MacLeish

September 20–through October
Grandma Moses
California Palace of the Legion of Honor, San Francisco. 22
paintings

October 18–November 12
*Exhibition of Recent Paintings by the Senior of American Primitive
Painters, America's Beloved Grandma Moses*
James Vigeveno Galleries, Los Angeles, Calif. 34 paintings.
Catalogue

Thanksgiving–Christmas
Ten Years–Grandma Moses
Galerie St. Etienne, New York. 42 paintings. Catalogue
includes *I Remember* by Grandma Moses (facsimile of her
handwritten manuscript)

1948–49 *Grandma Moses*
Traveling Exhibition: Montgomery, Ala.; Charlotte, N.C.;
Memphis, Tenn.; Monmouth, Ill.; Grinnell, Iowa; Racine,
Wis. 20 paintings

1949 January 9–30
Art in the United States, 1949
Museum of Fine Arts of Houston, Tex. Included 2 paintings
by Grandma Moses. Catalogue includes Introduction by
James Chillman, Jr.

May 8–31 (extended to June 9)
Paintings by Grandma Moses
The Phillips Gallery, Washington, D.C. 30 paintings

October 3–22
First Boston Exhibition of Paintings by Grandma Moses
Robert C. Vose Galleries, Boston, Mass. 19 paintings

November 6
St. Mark's Episcopal Church, Hoosick Falls, N.Y. One-man
show of 120 paintings and embroidered pictures

1950 January 30–February 18
Selected Paintings by Grandma Moses
The American British Art Gallery, New York. 20 paintings.
Catalogue includes Essay by Thomas Carr Howe, Jr.

September 7–October 15
*Grandma Moses: Exhibition Arranged on the Occasion of Her 90th
Birthday*
Albany Institute of History and Art, Albany, N.Y. 55
paintings and additional embroidered pictures. Catalogue

October 19–December 21
Pittsburgh International Exhibition of Paintings
Carnegie Institute, Pittsburgh, Pa. Included one painting by
Grandma Moses. Catalogue

June–December
Grandma Moses: 50 Paintings
Exhibition circulated in Europe under the auspices of the
U.S. Information Service: Vienna, Munich, Salzburg,
Berne, The Hague, Paris. Catalogue published by each
display center

December 10–January 15, 1951
Paintings by Grandma Moses
The Taft Museum, Cincinnati, Ohio. 32 paintings. Cata-
logue

1951 March–April
Grandma Moses: Twenty-Five Masterpieces of Primitive Art
Galerie St. Etienne, New York. Catalogue includes *My Tip-Up Table* by Grandma Moses; *About Grandma Moses* by Allen Eaton. Reviews and comments on the European Moses Exhibitions

April 9–28
Grandma Moses: Sixty of Her Masterpieces
The Dayton Company, Minneapolis, Minn. Catalogue

May 6–13
An Exhibition of Paintings by Grandma Moses
Brooks Memorial Art Gallery, Memphis, Tenn. 27 paintings. Catalogue

Grandma Moses
Traveling Exhibition: Kansas City, Mo.; Omaha, Neb.; Des Moines, Iowa; Tulsa, Okla. 26 paintings

1952 January 11–March 2
Paintings by Grandma Moses
Art Gallery of Toronto, Canada

March 5–21
Twenty Famous Paintings by Grandma Moses
The American British Art Gallery, New York. Catalogue

May–June
Grandma Moses
Syracuse Museum of Fine Arts (now Everson Museum of Art), Syracuse, N.Y. 23 paintings. Catalogue

October
Grandma Moses
The Memorial Art Gallery, Rochester, N.Y. About 30 paintings, 2 embroidered pictures

1952–53 *Grandma Moses*
Traveling Exhibition: Cedar Rapids, Iowa; Davenport, Iowa; Springfield, Mo.; Laguna Beach, Calif.; Windsor, Vt.; Wilmington, Del.; Houston, Tex.; New Orleans, La.; San Francisco, Calif.; Lafayette, Ind.; Terre Haute, Ind.; Birmingham, Ala.; Clearwater, Fla.; New London, Conn. 24 paintings

1953 February–March
Grandma Moses
Santa Barbara Museum of Art, Santa Barbara, Calif.

March 14–22
Art Exhibition: Grandma Moses
Part of the California International Flower Show under the auspices of the Los Angeles Municipal Art Commission Hollywood Park, Inglewood, Calif. 57 paintings

April–May
"A Grandma Moses Album": Exhibition of Recent Paintings
Galerie St. Etienne, New York. 26 paintings. Catalogue

December 18–early September 1954
American Painting, 1754–1954
Metropolitan Museum of Art, New York. Included one painting by Grandma Moses

1954 February 14–28
Grandma Moses
Buffalo Historical Society, Buffalo, N.Y. 29 paintings

October 19–November 21
Man and His Years
The Baltimore Museum of Art, Baltimore, Md. Included 2 paintings by Grandma Moses. Catalogue

1954–55 *American Primitive Paintings from the 17th Century to the Present*
Circulated in Europe by the Smithsonian Institution for U.S. Information Agency: Lucerne, Vienna, Munich, Dortmund, Stockholm, Oslo, Manchester, London, Trier. Included 5 paintings by Grandma Moses. Catalogue published by each display center

1954–56 *Grandma Moses*
Traveling Exhibition: Coshocton, Ohio; Rockford, Ill.; Davenport, Iowa; Seattle, Wash.; Duluth, Minn.; Oakland, Calif.; San Diego, Calif.; San Jose, Calif.; Elmira, N.Y.; Pittsburgh, Pa.; Fort Dodge, Iowa; St. Paul, Minn.; Clearwater, Fla.; Greenville, S.C. 20 paintings

1955 November 29–through December
A Tribute to Grandma Moses
Loan exhibition of paintings presented by Thomas J. Watson and the Fine Arts Department of the International Business Machines Corp. IBM Gallery, New York. 42 paintings. Catalogue includes Tribute by Thomas J. Watson; *Work and Happiness* and *My Tip-Up Table* by Grandma Moses

1955–57 *Grandma Moses*
Traveling Exhibition in Europe: Bremen, Stuttgart, Cologne, Hamburg, London, Oslo, Aberdeen, Edinburgh, Glasgow. 35 paintings. Catalogue published by each display center

1957 May 6–June 4
Grandma Moses: New York Showing of an Exhibition of Paintings Presented in Europe During 1955–1957
Galerie St. Etienne, New York. 33 paintings. Catalogue includes *Grandma Moses* by Hubertus, Prince zu Löwenstein; excerpts from European reviews

August 31–October 13
Grandma Moses: A Selection of Thirty-Four Paintings from Public and Private Collections
California Palace of the Legion of Honor, San Francisco. Catalogue

1958 October 4–November 2
Famous Paintings and Famous Painters
Dallas Museum of Fine Arts, Dallas, Tex. Included 5 paintings by Grandma Moses. Catalogue

1958–59 *American Primitive Paintings*
Circulated by the Smithsonian Institution: Southampton, N.Y.; Shreveport, La.; Indianapolis, Ind.; Chattanooga, Tenn.; Birmingham, Ala.; Davenport, Iowa; San Diego, Calif.; Louisville, Ky. Included 12 paintings by Grandma Moses. Catalogue includes notes on 20 artists

1960 July 30–August 14
Grandma Moses: 100th Birthday Loan Exhibition
Southern Vermont Art Center, Manchester. 20 paintings

Fall
100th Birthday Celebration Exhibition
Webb Art Gallery, The Shelburne Museum, Shelburne, Vt. 17 paintings. Catalogue

September 12–October 6
My Life's History: A Loan Exhibition of Paintings by Grandma Moses
Assembled on the occasion of the artist's hundredth birthday. IBM Gallery of Arts and Sciences, New York. 44 paintings and one embroidered picture. Catalogue includes Tributes by Governor Nelson A. Rockefeller, Otto Kallir,

Jean Cassou. Autobiographical notes accompany the pictures; all works illustrated. This exhibition, with the same catalogue, was subsequently circulated by the Smithsonian Institution to the following cities: Milwaukee, Wis.; Washington, D.C.; Chattanooga, Tenn.; Baton Rouge, La.; Seattle, Wash.; Laguna Beach, Fla.; Fort Worth, Tex.; Winnipeg, Canada; Chicago, Ill.

1962 April 28–29
Grandma Moses' Original Paintings
Hoosick Falls Central School, Hoosick Falls, N.Y. 95 paintings and embroidered pictures

November–December
Grandma Moses: Memorial Exhibition
Galerie St. Etienne, New York. 54 paintings. Catalogue includes *On the Style and Technique of Grandma Moses* by Otto Kallir

1962–64 *A Life's History in 40 Pictures*
Traveling Exhibition circulated in Europe: Vienna, Paris, Bremen, Hamburg, Hameln, Fulda, Düsseldorf, Darmstadt, Mannheim, Berlin, Frankfort, Oslo, Stockholm, Helsinki, Gothenburg, Copenhagen, Moscow. 39 paintings and one embroidered picture. Catalogue published by each display center

1963 June 29–October 22
The Home Country of Grandma Moses: Twenty of Her Best Paintings of Local Areas and Activities
The Bennington Museum, Bennington, Vt.

December 5–8
The Original Paintings of "The Night Before Christmas" by Grandma Moses
Rensselaer County Historical Society, Troy, N.Y. 10 paintings

1964 July–September
Die Welt der naïven Malerei
Salzburger Residenzgalerie, Salzburg. Included 4 paintings by Grandma Moses

July–October
De Lusthof der Naïeven. Le Monde des Naïfs
Museum Boymans-Van Beuningen, Rotterdam; Musée National d'Art Moderne, Paris. Included 2 paintings by

Grandma Moses. Catalogue includes essays by Jean Cassou, J.C. Ebbinge Wubben, and Oto Bihalji-Merin. Biographical notes

1964–65 December 14–January 9, 1965
My Life's History: Paintings by Grandma Moses
Forty paintings which toured seventeen European cities; in addition, 25 pictures never previously shown. Hammer Galleries, New York. Two Catalogues

1965 July 17–31
Grandma Moses Art Festival: A Loan Exhibition
The Buck Hill Art Association, Buck Hill Falls, Pa. 35 paintings. Catalogue

December 7–24
Forty Grandma Moses Paintings Never Shown Before
Hammer Galleries, New York. Catalogue

1966 July 26–October 2
1st Triennial of Insitic Art
Slovenska Národná Galéria, Bratislava, Czechoslovakia. Included 11 paintings by Grandma Moses. Catalogue

1966–72 *An Exhibition of Mementos*
Grandma Moses Schoolhouse, Eagle Bridge, N.Y.

1967 June 9–October 24
Paintings by Grandma Moses: Twenty-Three of Her Best Paintings of Local Areas and Activities
The Bennington Museum, Bennington, Vt.

December 5–30
Paintings by Grandma Moses
Hammer Galleries, New York. 28 paintings. Catalogue includes *An Appreciation* by John Canaday

1968 May 1968–December 1972
The Grandma Moses Gallery
The Bennington Museum, Bennington, Vermont. 81 paintings, the "tip-up" table, documentary material on the artist's life and career

The Grandma Moses Schoolhouse was transferred from Eagle Bridge to the Bennington Museum, where a continuing Grandma Moses exhibition takes place.

1969 February 20–March 30
Art and Life of Grandma Moses
Paintings from American museums and private collections; in addition, *The Grandma Moses Gallery* of the Bennington Museum. The Gallery of Modern Art, New York (now New York Cultural Center). 151 paintings, the "tip-up" table, documentary material. Catalogue: Edited by Otto Kallir. Includes documentary material and previously published writings by and about Grandma Moses. Published by The Gallery of Modern Art, New York; A.S. Barnes & Co., South Brunswick and New York; Thomas Yoseloff, Ltd., London

December 2–30
Grandma Moses
Hammer Galleries, New York. 43 paintings. Catalogue

1971 December 6–31
Grandma Moses
Hammer Galleries, New York. 28 paintings. Catalogue

1972 February 22–March 11
Four American Primitives: Edward Hicks, John Kane, Anna Mary Robertson Moses, Horace Pippin
ACA Galleries, New York. Included 15 paintings by Grandma Moses. Catalogue

April 21–May 7
Paintings by Grandma Moses
Old Capitol Museum, Jackson, Miss. 15 paintings. Catalogue

1974 November 17–December 24
Christmas in the Country
10 paintings by Grandma Moses re-created three-dimensionally by James Bakkom of the Guthrie Theatre. Also an exhibition of 26 pictures by Grandma Moses and documentary material. Dayton's, Minneapolis, Minn.

1974–75 November–March
"Die Kunst der Naïven"
Haus der Kunst, Munich; Kunsthaus, Zurich. Included 5 paintings by Grandma Moses. Catalogue

Index

The titles of works by the artist are in Roman type. References to documentary photographs are in italics. The numbers refer to plates; colorplates are indicated by an asterisk*.

1000